WITHDRAWN

Transforming Type

Property of
Fort Bend County Libraries
Not for Resale

D1224048

Transforming Type

New directions in kinetic typography

BARBARA BROWNIE

B L O O M S B U R Y

LONDON • NEW DELHI • NEW YORK • SYDNEY

Bloomsbury Academic

An imprint of Bloomsbury Publishing Plc

50 Bedford Square	1385 Broadway
London	New York
WC1B 3DP	NY 10018
UK	USA

www.bloomsbury.com

BLOOMSBURY and the Diana logo are trademarks of Bloomsbury Publishing Plc

First published 2015

© Barbara Brownie, 2015

Barbara Brownie has asserted her right under the Copyright, Designs and Patents Act, 1988, to be identified as Author of this work.

All rights reserved. No part of this publication may be reproduced or transmitted in any form or by any means, electronic or mechanical, including photocopying, recording, or any information storage or retrieval system, without prior permission in writing from the publishers.

No responsibility for loss caused to any individual or organization acting on or refraining from action as a result of the material in this publication can be accepted by Bloomsbury or the author.

British Library Cataloguing-in-Publication Data
A catalogue record for this book is available from the British Library.

ISBN: HB: 978-0-8578-5767-5
PB: 978-0-8578-5633-3
ePDF: 978-0-8578-5533-6
ePub: 978-0-8578-5566-4

Library of Congress Cataloging-in-Publication Data
A catalog record for this book is available from the Library of Congress

Typeset by Fakenham Prepress Solutions, Fakenham, Norfolk NR21 8NN
Printed and bound in India

Contents

List of Illustrations

List of figures

List of plates

Introduction

Towards a classification of temporal typography

Static typography has been thoroughly categorized. Existing classification systems provide typographers with valuable tools for understanding their medium, and a language with which artifacts and experiences of artifacts can be efficiently described. Furthermore, they allow analytical comparisons of each category. Indeed, Jonathan Hoefler (2001, p. 201) suggests that a "universally applicable typeface classification system" is "a Holy Grail of typography." Existing classification systems differentiate between the various visual properties of typefaces, such as roman and sans serif typefaces. Vox's *Nouvelle Classification des Characters* (of 1954) identifies 11 categories of type, and forms the basis for most contemporary classification systems (Dixon, 2002). While these classifications are valuable, they do not yet incorporate the additional features that are presented in temporal typography.

Existing taxonomies of "typographic forms" for the screen have largely been based on the "tradition of print typography" (Ford et al., 1997, p. 269). As Catherine Dixon (2002) observes, "text is increasingly found in environments outside of print," and typography is inevitably acquiring attributes, which cannot be classified according to any system that was designed before the advent of "new technologies." With the dynamic capabilities of screen-based media, "our static definitions of type appear increasingly imperilled" (Helfand, 1997 [1994], p. 51). The problem of definition increases with temporal artifacts, which complicate existing notions of the nature of the letterform, through the addition of kinetic behaviors. Since they have been developed primarily to classify static typefaces, classification systems are arranged according to visual properties. In temporal typography, letterforms cannot be described by those properties alone. While they do exhibit similar visual properties as in print, they are also differentiated from one another in the way that they move or behave. New classification systems need to be developed in order to take account of "both spatial and temporal factors" (Bork, 1983, p. 207).

Literary scholar Teemu Ikonen (2003) suggests that "one of the decisive dividing lines between digital literature and print literature" is "textual motion." It is now possible for objects to "move" on screen, insofar as they are perceived as being in motion when displayed sequentially in quick succession. Matt Woolman and Jeff Bellantoni (1999) describe this as "type in motion." Graphic design critic Michael Worthington (1998, p. 9) observes, "in a time-based medium, type has additional expressive qualities, additional layers of significance." Temporal media offer typographers opportunities to "dramatize" type, for letterforms to become "fluid" and "kinetic" (ibid.; Kac, 1997 [1996]; Engel et al., 1999). Film title credits present typographic information over time, often bringing it to life through animation. Motion graphics, particularly the brand identities of film and television production companies, increasingly contain animated type. Software such as

Adobe Flash and After Effects has prompted the creation of many recent examples of animated poetry and kinetic typography. Examples of "type in motion" in temporal media have become commonplace.

Multimedia offers more than just the opportunity for motion. Michael Worthington (1998, p. 9) observes that in digital screen-based media, a "fully navigable," "three-dimensional typographic environment" may be created. As demonstrated in J. Abbott Miller's (1996, p. 2) exploration of "dimensional typography," it is no longer necessary to understand letterforms as being flat signs. Instead, they can be experienced as having both "spatial and temporal dimensions." Letters have become "architectural, ergonomic, and cinematic." The space which letters occupy has also changed, from a flat plane to an "environmental, immersive" space, in which type can be arranged and layered within four dimensions: three spatial, and one temporal. These kinds of typography appear in a number of different screen-based media, including film and television credit sequences, motion graphics, animation, and digital arts. This range of media reflects the range of environments in which temporal typography, and specifically transforming (or "fluid") typography, may be found.

In new on-screen typographic environments we must consider verbal forms, including letters, numbers, and other characters, in new ways. Although there is an established discourse about the field of temporal typography as a whole, and identification of many of the key features of temporal and digital typographic environments, there is very little existing discussion of the various behaviors exhibited within some contemporary typographic artifacts. Texts by Woolman and Bellantoni (1999), and Johnny C. Lee et al. (2002), describe "motion" or kineticism, but rarely differentiate between different kinds of kineticism. In particular, motion and "other temporal change" are rarely distinguished from one another, and where they are acknowledged, these "other kinds of change" are not fully explored (Lee et al., 2002, p. 81).

The primary aim of this book is to identify and categorize the variety of behaviors that are seen in contemporary examples of temporal typography. Practitioners in the field of temporal typography frequently describe their work by likening it to relevant previous artifacts.[1] Theorists and commentators currently make generalizations and omissions similar to those made by practitioners.[2] Practitioners, like critics, students, and scholars, have sometimes fallen into the trap of describing their work using vague or misleading language, because there is no agreed-upon definition of a particular term, or because there is a lack of more accurate terms.[3] This book aims to resolve this problem, providing practitioners with the language to describe how their work is not only similar to, but also distinct from, existing works. The new categories and terminology identified in these pages will inform practitioners and others of the possibilities of new kinds of temporal behavior, such as fluidity, and thereby encourage further experimentation and development of practice. Meanwhile, theorists and commentators will benefit from the typology presented here by gaining terminology to more accurately define artifacts. This will in turn encourage clearer and more extensive analysis of artifacts.

This audience of practitioners, theorists, and commentators may exist in a number of different disciplines, as temporal typography is not limited to a particular medium. Kinetic behaviors may exist in a number of different media, including film and television, motion graphics, and digital arts, and may be created using a variety of different handmade or digital methods. It is therefore the case that the categories presented here will be useful to audiences in multiple disciplines. In order to address this diverse audience, the book uses examples from different fields and methods that have been applied in different disciplines. This interdisciplinary approach

is becoming increasingly useful as, more than ever before, multi-platform artifacts exist between media. Film title sequences and television idents, for example, are frequently removed from their original context and placed online, where they will be viewed by various audiences, and set apart from whatever narrative may have followed or preceded them in their original, intended, context. Moreover, there has recently been an increase in "hybrid fields" which may only be adequately explored through an interdisciplinary approach (Thompson Klein, 1990, p. 11). The aim of this book is not to classify artifacts according to the medium in which they exist (a task which has already been carried out by, most notably Woolman and Bellantoni),[4] or by the features that are also applicable in static print (such as color or size), but according to the behaviors they exhibit. These temporal behaviors are independent of medium, and so it is necessary to explore them by looking beyond the medium in which any particular example is contained.

Part One of this book identifies main categories of temporal typography, some of which have been proposed before, and others of which are unique to this study. These categories identify the behaviors, or kinetic processes, that are seen in temporal typography. Chapter 1 makes the distinction between the *serial presentation* of static type, and *kinetic typography*. It identifies how *kinetic typography* is distinct from other forms of on-screen typography. It then shows the variety of kinetic behaviors that can exist on screen, including several kinds of *scrolling typography* and *dynamic layout*. Chapter 2 discusses the difference between global and local kinds of change, proposing that motion (as in, change of location affecting overall layout) is distinct from *local kineticism*, which affects the appearance and meaning of individual letterforms. Many commentators fail to distinguish between global and local kineticism, often assuming that the behaviors may have universally the same consequences. This omission is perhaps responsible for the lack of discussion about the ways that local behaviors can affect the identity of individual letterforms. This chapter attempts to resolve the problem by highlighting the difference between the possibilities presented by *global* and *local kineticism*. Chapter 3 goes on to explore *local kineticism*, with particular emphasis on fluid typography. Building on the work of Eduardo Kac, *fluid typography* is identified as type or lettering that transforms to the extent that its identity and meaning are dramatically altered, to the extent that it can no longer be recognized as alphabetic. The categories of *fluid typography* are identified, showing the different behaviors that allow a letterform to abandon one identity and adopt another.

These categories, as identified in the first section of the book, are presented in the diagram, Figure 1. The diagram clarifies the distinction between the various categories and sub-categories of behavior exhibited in contemporary temporal typography. These behaviors are classified using a combination of existing and new terms. Where existing terms are sufficient and appropriate to describe a behavior, they have been used in accordance with established definitions that exist elsewhere (often transposed from another field of practice, but applicable in temporal typography). Where there is no existing terminology, terms have been developed that aim to clearly describe a behavior and distinguish it from others. This typology aims to contribute to the field of temporal typography by enabling identification, description, and differentiation of kinetic artifacts, or artifacts that contain kinetic forms, with particular emphasis on those that can be termed *fluid*.

Part Two identifies factors that enable type to transform, and explores issues that arise as a consequence of transformation. Chapter 4 addresses the screen as a container for illusory three-dimensional (3D) space, and will show how this enables some forms of fluid transformation, specifically, *revelation* and *construction by parallax*. These categories of fluidity exploit

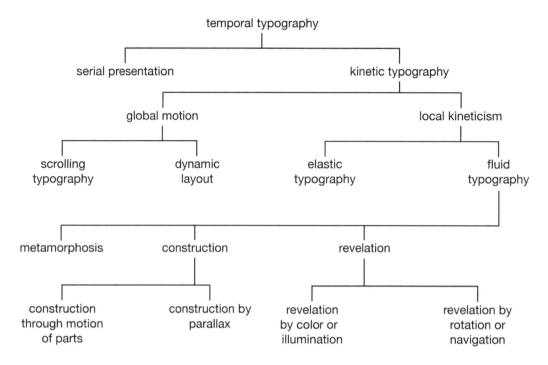

Figure 1 *The categories of behaviors exhibited in temporal typography that are explored in this book.* © *Barbara Brownie.*

the characteristics of 3D objects or space to present an apparent emergence of letterforms. Chapter 5 addresses the consequences of typographic transformation. It extends debates about the importance of legibility, and argues that existing debates must change in order to address the possibility of a form that is only temporarily alphabetic. It observes that when a form is fluid, legibility fluctuates. Fluid letterforms go through phases of legibility and illegibility, or "asemisis" (when they apear to be alphabetic but escape precise definition). Chapter 6 identifies that some kineticism may occur as a consequence of input from external forces, such as user activity. It demonstrates that some temporal typography is reactive or generative, exhibiting kinetic behaviors only under certain influences. This chapter does not intend to be an extensive exploration of interactivity (as interactive media have been widely theorized elsewhere, most notably by Lev Manovich), but rather it makes the important observation that not all temporal behaviors are pre-determined or automatic.

The final section presents examples for analysis. It demonstrates how fluidity occurs in examples of television idents, credits sequences, typographic animation, and kinetic poetry. The range of examples presented here have been selected for the extent to which they exemplify the categories identified in the typology, and typify the range of fluid behaviors that are exhibited in contemporary temporal typography. Chapter 7 explores the behaviors exhibited in Channel 4 idents, and how they have evolved from Martin Lambie Nairn's original 1982 ident, to MPC's more recent photorealistic idents. Analysis shows how the Channel 4 logo is constructed either through the independent motion of colored polygons, or through *parallax*, prompted by the tracked navigation of the viewer.

The chapter further shows the extent of the influence of this canonical ident, identifying examples such as the "Big 4" sculpture, and other transforming broadcast logos from Five and MTV. Chapter 8 explores a selection of credit sequences by Kyle Cooper, including *Transformers* and *True Lies*. It explores the adaptability of Cooper's style, focusing primarily on his treatment of letterforms. It demonstrates Cooper's influence on the field through comparison to recent and current sequences from film and television. The final chapter introduces recent and experimental works of kinetic poetry that employ transformation of typography. Work is selected from Dan Waber, Eduardo Kac, and others. These practitioners work across a variety of media, including typographic animation and interactive video, but are united in their use of fluid typography.

All of the examples explored in the following pages, and a range of other artifacts, may be accessed via the website that accompanies this book, www.fluidtype.org

A note on terminology

Throughout this book, the term "typography" is used to describe the appearance and arrangement of letterforms. This term is commonplace in discussions of screen-based artifacts that feature alphabetic or numerical forms. Although the texts referenced in this book differ on their use of the terms to describe different kinds of on-screen behavior, they agree on their application of the term "typography" in all cases.

The invariable use of the term "typography" in the writings explored in this book is in contrast to the situation in static media, where texts such as Willen and Strals' *Lettering & Type* (2009) distinguish between "typography" and "lettering." Nicolete Gray (1982) identifies "lettering" as a manual practice, in which letters are drawn or written (as in calligraphy and drawn or painted letterforms). "Typography" is commonly used to refer to text that has been produced using a designed, or "prefabricated" typeface (Donaldson, 2009). It has been typed using a keyboard (then displayed on screen or print), or is the product of a combination of movable type and a printing press. The difference between typography and lettering may therefore be considered a question of ownership. Essentially, as Tim Donaldson (ibid.) has observed, lettering is created by the reader, but typefaces are borrowed. In lettering, forms are created, but in typography, forms are recontextualized.

In many examples of "temporal typography" which are presented in this book, many letterforms do not originate from the keyboard, perhaps rendering the term "typography" inappropriate. There are examples which originate from typed forms, but are not strictly typographic. In the case of Channel Five idents (see Chapter 3), the contours used as the model for a configuration of objects are based on a typed form (using the same typeface as the Five logo), but are designed in imitation of typed forms rather than directly typed. In other cases, where a letter or number is constructed from component parts, there is no connection to an existing typeface. In Channel 4 idents (see Chapter 6) each form is more fundamentally an arrangement of objects than it is type, presenting a form that does not belong to a particular character set. It is composed of image objects, not via the use of the keyboard. There are also examples that can readily be referred to as lettering. Dan Waber's *Strings* (see Chapter 8) is overt in its aesthetic similarity to handwriting.

In these examples, and many of the artifacts presented in this book, the focus of kineticism is not overall typographic arrangement but the form and identify of individual letters or numbers. While terms such as "lettering" and "typography" often focus on the practice, or overall artifact, it is more useful for this study to use terminology that describes the individual forms that are affected by kineticism. Heller and Thompson (2000), and Willen and Strals, whose texts deliberately focus on combinations of typography and lettering, offer the term "letterforms" (2009, p. 1). This term is applicable in many cases, as letters may be written, drawn or typed. "Letterform" is a term that is applicable in both typography and lettering, and therefore more universally applicable than other terms. It also addresses the form itself, rather than the wider practices or complete artifacts in which those forms exist.

In adherence to these existing applications of the terms "typography" and "letterform," this book uses both terms where it is deemed appropriate by the author. "Typography" is used to describe wider practices and overall arrangements, and is not intended to exclude the possibility that those arrangements may include lettering. The term "letterform" is used to describe individual alphabetic or numerical forms, and is not intended to exclude other related characters such as punctuation marks.

It is further useful to acknowledge the distinction between different practices that are widely categorized as "typography." Within the field of typography, there are not only divisions between typography and lettering, but also between type design and typographic layout. Typography, and the wider field of graphic design, involves the arrangement and application of typefaces, while type design—the development of fonts and typefaces—focuses primarily on the design of letterforms. As Peter Bil'sk (2005) observes, "fonts are essentially modest semi-products; they don't have much meaning until they are used." Likewise, Donaldson (2009) argues that a type designer designs typefaces for use in multiple contexts; a typographer puts those "prefabricated" typefaces to use, focusing on their application in a particular context and composition. In this way, an act of typeface design precedes an act of typography.

This distinction between type design and typography will become vital in this book because it highlights an existing distinction between global and local design. Type design, involving the development of individual letterforms, requires a local focus, whereas typography typically involves arranging prefabricated letterforms on a page or screen, and thus requires a global focus. The distinction between these two roles is becoming increasingly blurred, as typographers now have access to digital tools that will allow them to manipulate existing typefaces. With these tools, the practice of typography has begun to resemble the practice of lettering.

The categories of temporal typography presented in this book rely on this distinction between local and global, with the creation of letterforms presented as distinct from the application of pre-existing typefaces. As will be explored in more detail in the first part of this book, this distinction, which already exists in static typography, is useful in distinguishing the main categories of kinetic typography, involving global and local kineticism.

PART ONE

Mapping the field: Categories of kineticism

1

What is kineticism?

Typography in temporal media

Increasingly, graphical signs including letterforms are being integrated into film and television. These two elements were once distinct, as directly filmed content was visibly different from graphical overlay. Now, however, on-screen typography is so effectively integrated into background environments that it is often treated similarly to any other visually recorded subject. It has become so complex that it is capable of dynamic performance.

Temporal media offer typographers opportunities to "dramatize" type, for letterforms to become "fluid" and "kinetic" (Woolman and Bellantoni, 1999; Kac, 1997; Engel et al., 2000). Film title credits present typographic information over time, often bringing it to life through animation. Motion graphics, particularly the brand identities of film and television production companies, increasingly contain animated type. Type is often overlaid onto music videos and advertisements, often set in motion following the rhythm of a soundtrack. Temporal typography is also increasingly found in experimental works, such as animated concrete poetry.

In temporal media, there is often a requirement to display information in text form. Largely, such text is informative (listing cast and crew of films and television shows, providing further details about an advertised product, or labeling content). As these are largely creative media, on-screen typography has developed to become expressive, helping to establish the tone of associated content or express a set of brand values. In title sequences, typography must prepare the audience for the film by evoking a certain mood. In an ident or bumper, it must express the brand values of a corporation. It may do this using the conventions of print, such as choice of typeface or color, but may also utilize a set of tools that are exclusive to temporal environments, such as expressive motion. To suit temporal output, much of this expression is achieved through kineticism. Letters become "a theatrical component" that can be brought to life through motion (Helfand, 1997 [1994], p. 51).

Fundamental to most examples of temporal typography is the notion that typography can be visually as well as verbally expressive. This notion has been subject to fierce discussion in the field of printed typography, with conflicting views from modernist and postmodern

typographers over the merits of type as a verbal or visual form of communication. Those who adhered to the modernist view (Jan Tschichold and Beatrice Warde in particular) proposed that the primary purpose of typography was to communicate clear linguistic messages. Whereas, more recent practitioners including Neville Brody and David Carson have explored typography that is visually expressive, with stylistic features that enhance or interfere with linguistic clarity. In the temporal environment, this debate is still applicable, but complexified by the potential for kinetic expression. Traditional, static characteristics, such as "bold and italic," offer only a fraction of the expressive potential of dynamic properties (ibid., pp. 49–50). Indeed, the use of kineticism in temporal typography is a tacit admission that typography can convey more than just linguistic meaning. Letterforms that jump and dance can convey joy, those that slump can convey sorrow, and those that vibrate can convey frustration. All of these messages are expressed in addition to whatever linguistic meaning is denoted by the word itself.

These expressive capabilities were initially explored in early stop-motion animation, including George Méliès' "animated letterforms" for advertisements in 1899 (Woolman and Bellantoni, 1999, p. 7). Over the course of the twentieth century, other temporal media began to feature typography, and to utilize potential for kinetic expression. In 1903, Edwin S. Porter's *Uncle Tom's Cabin* contained the first intertitles: "animated, filmic intertitles, with swirling or moving letters that formed words" (Ivarsson, 2004). Cinema audiences had their first experiences of title sequences in the 1950s. Saul Bass turned lists of credits into dynamic, typographic events when he developed his first title sequence for Otto Preminger's *Carmen Jones* (1954). As Bass—and later imitators—explored the potential of typography in credit sequences, other temporal media also continued to develop kinetic typographic expression. Norman McLaren's advertisement for the Canadian Tourist Board (1961), featured animated letterforms that were "dramatized," to the extent that they were given the characteristic "swagger" of comedy performers (Hutchings, 1964, cited in Woolman and Bellantoni, 1999, p. 8). What was notable about all of these early examples is that they were not generated digitally.

Many contemporary examples of temporal typography are computer generated. Digital technology does offer tools to make typographic animation quickly and easily, to the extent that many commentators view kinetic typography as a recent innovation that has arisen directly as a consequence of "digital environments" (Ikonen, 2003; Hostetler, 2006; Small, 1999). However, temporal typography is not just a product of the digital age. On-screen typography is frequently not generated by computers. It is possible to produce temporal typography using directly filmed objects and stop-motion techniques. Indeed, there are numerous examples which pre-date digital technology. George Méliès' "animated letterforms," for example, appeared on the analog screen in the nineteenth century (Woolman and Bellantoni, 1997, p. 7). Such examples demonstrate the use of manual techniques for screen-based artifacts long before the emergence of recent digital technology. Throughout the twentieth century, practitioners continued to develop manual and analog techniques to animate lettering and typography, including celebrated titles sequences of Saul Bass and Robert Brownjohn.

When Saul and Elaine Bass produced the opening credits for *Alcoa Premier* (1961), their subject was a static model, filmed directly from life. The camera navigates around a physical model of an urban landscape to reveal letters hidden within. In this example, the model landscape is static, but the viewer's experience of this artifact is temporal. Through filming, the static objects are transformed into a temporal event. Robert Brownjohn's sequence for *From Russia With Love*

(1963) was similarly dependent on real-life objects and events. In Brownjohn's titles, the opening credits are projected onto the body of a belly dancer. The dancer's movement causes it to stretch and skew as it flows across the curves of her body. Made illegible by this distortion, the text can only be read once the dancer has moved away, and the type lands on a flat backdrop. Although this sequence involves projected forms, and is viewed on screen, its production involved only analogue technologies, and is notable in its minimal use of contemporaneous technology. Brownjohn described his method as "instant opticals," in reference to the immediacy of the filmed sequence in contrast to the lengthy laboratory processes that had previously been used to create credit sequences (King, 1993).

Bass and Brownjohn's use of real-life objects was a creative choice, not a necessity imposed by the limitations of technology available at the time. From the 1960s, "the possibilities of moving text" were developed in many "hybrid forms," electronically combining written text with video and film, electronics, and digital technology. "Video poetry was developed by, among others, E. M. Melo e Castro, Richard Kostelantz and Arnaldo Antunes from the '60s onwards" (Ikonen, 2003). Notable artifacts included *Poem Fields* (1964–6), computer-generated typographic animations by Stan Vanderbeek and Ken Knowlton.

Even contemporary practitioners do not always restrain themselves to the possible outcomes allowed by software. Many have chosen to use manual techniques, finding that they produce a gritty irregularity that is a pleasing contrast to the crisp perfection of digitally generated contours. Kyle Cooper, whose work will be addressed in more detail in Chapter 8, is celebrated for varying his style and methods. For the title sequence for *Seven* (David Fincher, 1995) he created lettering by manually scratching into film stock. The resultant writing had expressivity that would have been impossible to achieve with a digital typeface. Even 3D temporal typography can be created without digital intervention. Sculptural letters, that are real-life objects, can be subjected to manual treatments, and those processed can be filmed directly.

Dan Pedley's "Q Fire" provides contemporary evidence that temporal typography can be created using manual techniques. This piece is a directly filmed sequence, in which matches arranged to form the shape of a "Q" are set alight (see Plate 1). As the matches ignite one another, a flame spreads around the contours of the letter. Though this domino effect is staged, there is no digital interference. The unpredictability of real fire gives the sequence irregularity that would be difficult to replicate in clinical digital alternatives.

Since such examples do not require digital technology in their production, temporal typography cannot be considered to be entirely technologically motivated. However, it is through digital technology that such examples reach their audience. The surge in the number of available examples may be less due to the technology of production, and more a result of new methods of distribution, mostly online via YouTube, Vimeo and other video-sharing sites. Videos gathered on YouTube provide a wide variety of creative output as well as video tutorials aimed at sharing temporal typography techniques with audiences. As Neil Bennet (2007) observes, regardless of the method of production, it is "output" media and new distribution channels that have "helped to evolve the medium of motion typography," expanding audiences and increasing awareness among designers of the possibilities of typographic behaviors. Temporal typography is no longer viewed as a prelude to a larger artifact (as in credit sequences), or a bumper between shows (as in television idents), rather it is deemed worthy of viewing and sharing as a standalone creative artifact.

Temporal typography

The screen is a site for many forms of typography. Static type is located in word processing packages, within documents, and websites. In these environments, type is susceptible to change at the user's instruction, as new fonts and sizes are selected, but is not otherwise "temporal." Temporal typography is distinct from other forms of on-screen typography as it is situated within temporal media (such as film and television). Its state is directly affected by time, as its appearance is linked to a particular moment within a sequence.

In 1995 and 1996, Y. Y. Wong produced the first extensive analyses of "temporal typography," in which she characterized the many forms of temporal behaviors that can be observed in late-twentieth-century on-screen typography. Wong identified that temporal typography is not simply type on screen, rather type that performs in ways that it cannot on the printed page.

Typography on screen, including temporal typography, does feature many of the key characteristics of typography and lettering in print forms. Color, size, typeface, and layout are as much a concern for the temporal typographer as for the traditional graphic designer. However, Wong (1995, p. 8) warns of the dangers of classifying temporal typography in the same terms as print. She recognizes that temporal typography introduces new "issues" which did not exist in print, and which therefore require new methods of analysis and description.

Serial presentation

In temporal media, typography has the potential to diverge from print. We can no longer simply classify type according to its appearance (qualities such as font, size, color), as in temporal environments those static properties are overshadowed by behaviors: qualities of movement and change (ibid., p. 11). Temporal behaviors, including "flashing" or "blinking," directional motion, distortion or transformation, provide additional expressive tools for the typographer (Bork, 1983, p. 207). These behaviors are exclusive to temporal environments, and invite us to assess typography in new ways.

One key contribution of Wong's study of temporal typography is that she differentiates between kinetic typography and type that happens to exist in a temporal environment but is otherwise static. Many examples of type within film and television do not display motion of any kind. Title cards, "initially the only method for putting type on the screen," are printed typographic designs, directly filmed (Wong, 1995, p. 15). Static title cards, television test cards, and other static arrangements can be assessed in similar terms to printed equivalents. They are designed with the same tools as a printed piece of typography, and the fact that they are captured for temporal display is almost incidental.

Wong identifies this *serial presentation* as distinct from typography which exhibits motion or change. *Serial presentation*, though existing in temporal media, presents a series of still typographic arrangements, none of which are independently reliant on a temporal dimension. In *serial presentation*, words neither move nor change, and are, in all respects, arranged and displayed in the same way as words on a printed page. Such text is only set apart from its cousins in print by the fact that its appearance is linked to a particular moment in time.

Serial presentation of static words is frequently used to accompany or encourage speech. The pace of presentation of words on screen can reflect the rhythm and speed of reading. It may accompany a voice-over, as reinforcement of spoken dialogue, or may be silent, prompting the viewer to read aloud. This makes *serial presentation* of typography ideal for experiments that explore the relationship between reading and speaking. It has been used in research into reading processes and legibility. One method of presentation used in cognitive psychology research has been referred to as *RSVP* ("Rapid Serial Visual Presentation") in which text is presented "in the same location serially" (Wong, 1995). RSVP is commonly considered to have practical, rather than creative, applications. It is employed as a reading aid and diagnostic tool for dyslexia (Spence and Witkowski, 2013, p. 2). It is also a valuable tool in contexts where readers must absorb a large quantity of written information in a short time, as it encourages a faster reading speed than linear arrangement of words (Beccue and Villa, 2004, p. 43).

Serial presentations may feature a number of transitions which can create the impression that the text is in some way dynamic. Cinematic transitions including fades (between two different still frames) or wipes (which reveal the next frame as if it were hidden behind the last) can be used as an alternative to a simple cut from one still typographic composition to the next (Woolman and Bellantoni, 1999, p. 58). Although these transitions may themselves be kinetic, the text compositions to which they are applied remain static. If the content of these static typographic arrangements is not set in motion, it cannot be said to be fully utilizing the potential of temporal media. It is only when kinetic behaviors are introduced that temporal typography begins to move dramatically away from its origins in print. It is therefore important to establish a distinction between two main categories of temporal typography: static type that is serially presented over time, and *kinetic typography* that is seen to move or change.

Lee et al. offer the term "kinetic typography" to describe moving or changing text (Lee et al., 2002, p. 81). As Soonjin Jun (2000) agrees, this term can be used to broadly define not only type that is "moving," but type which exhibits any kind of motion or change. In is in kinetic typography that the true potential of temporal media may be realized.

Scrolling typography

Kineticism can range from basic scrolling motion to more complex transformation. In *scrolling typography*, a typographic arrangement remains stable, but moves in relation to the frame of the screen. Distances between letters and words are fixed, and the whole composition is re-framed over time. In a basic scrolling credit sequence, a list of words may rise from the bottom to the top of the screen, or from left to right. This is equivalent to a camera tracking or panning across a static typographic arrangement.

The celebrated scrolling narrative which opens *Star Wars Episode V—The Empire Strikes Back* (Kershner, 1980), was not literally moving. Rather, the text was a print, laid flat on a table. The print was filmed directly, with the camera, tethered to a horizontal wire, tracked from the top to the bottom of the printed text. The resultant receding scroll presented the illusion of moving text, when in reality it was the camera that was in motion.

Even when *scrolling* credits are created digitally, all motion is relative. The typographer begins with a static arrangement, and then positions it outside of the viewing frame. An endpoint is set on the opposite side of the frame, and the typography is set on a trajectory from one point to another. At any moment in the sequence, the frame contains a portion of the overall typography arrangement.

Scrolling may be more complex when the screen is treated as a 3D environment, capable of containing depth. Type may scroll across a plane (left to right, or up or down, on x and y axes, see Figures 1.1–1.2), and may also scroll forward or backwards, along the z axis, as if advancing or receding (see Figure 1.3). In this case too, a static arrangement is reframed to create relative motion. Three-dimensional scrolling can create an effect similar to a camera zooming in or out, or approaching or withdrawing from a subject.

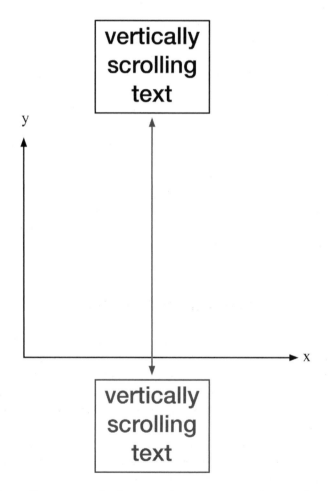

Figure 1.1 *Vertically scrolling text is a fixed typographic arrangement that usually originates and terminates off-screen. It is set in motion, traveling on a trajectory that moves up or down the screen, so that the frame of the screen contains a different part of the composition at different moments in the sequence.* © *Barbara Brownie.*

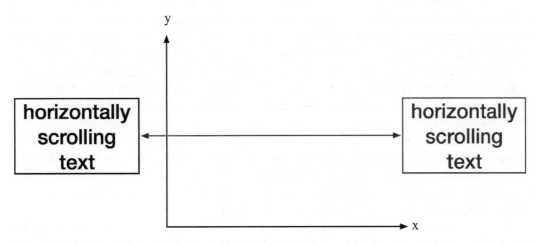

Figure 1.2 *Horizontally scrolling typography travels from left to right, or right to left. Diagonal or other 2D paths are also possible. © Barbara Brownie.*

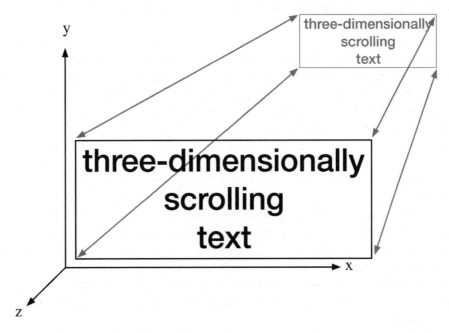

Figure 1.3 *In a 3D scroll, the fixed typographic arrangement moves along the z-axis, as if advancing or receding. This may be combined with a scroll along x and y axes. © Barbara Brownie.*

Treatment of the typographic arrangement as a static object has the advantage of allowing designers to treat the typography as they would a directly filmed scene. Typography may be overlaid onto live-action footage, alongside other objects. The typography may then be set in scrolling motion at the same pace as objects within the filmed scene. If the scroll mimics the movement of the cameras' navigation through the scene, the text can appear to be embedded with the landscape.

In Picture Mill's opening sequence for *Panic Room* (David Fincher, 2002; Plate 2) the names of cast and crew appear as if they are colossal architectural structures hovering above the Manhattan skyline. This impression is aided by the fact that the letterforms are rendered to look like 3D objects, and skewed as if receding parallel to the buildings in the scene. The raw footage of Manhattan slowly pans down streets and across rooftops. The typography, which has been overlaid later using 3D motion tracking, scrolls so that its motion across the screen exactly matches the pan of the live-action backdrop. Such sequences reveal the similarities between scrolling typography and the many conventions of cinema.

As in many recent examples, this sequence aims to convey a sense that the type is a directly filmed object, naturally occurring in the filmed environment. Letterforms are rendered so that they appear to resemble an object within the scene. Typography has historically been seen as "unmotivated," or having "no natural connexion in reality" (Saussure, 1983 [1913] , pp. 67–9). In these examples, however, the visual appearance of the letters is motivated by the surrounding scene. This anchors the words into the scenery, blurring the boundaries between the visual and verbal, and between the diegesis of the film and the reality of its production. When appearance of the letterforms imitates the appearance of the scenery, the credit sequence bridges the gap between fact and fiction. The text of the credits relates to the production of the film, while the scene that forms the backdrop is an introduction to the setting of the film's narrative. By being embedded in the scene, the credits merge into the fiction, thereby supporting the audience's transition into fantasy as the film begins.

Picture Mill's journey through a landscape, punctuated by typographic forms, demonstrates how scrolling can be an exploration of space. A space can exist as a landscape or typographic arrangement that is larger than the frame of the screen. Scrolling is a method of touring that space. The landscape is revealed to the viewer according to a predetermined path, planned by the designer. By controlling the scrolling action, the designer selects the order in which parts of the landscape are revealed, and so presents that space as a particular narrative.

Jacob Gilbreath uses a single 3D digital model as the subject of his kinetic typography (Figure 1.4). In this typographic animation, the camera pans across the model, tilts, zooms in, and pulls out. The motion of the camera is more complex than a simple scroll, as it involves a number of different directional movements across all three axes. It approaches and withdraws from the typographic composition, scrolling along the z-axis, while simultaneously panning over the surface, along the x and y axes. As the camera journeys across the model, it reveals increasingly more of the typographic arrangement, until finally the camera pulls back to reveal the complete model in its entirety. The phrases that appear within the model are not arranged in sequence. The object could therefore not be read if viewed as a whole. The planned sequence of phrases, as revealed by the path of the camera, turns an apparently chaotic arrangement of phrases into a coherent narrative.

Gilbreath's work employs combinations of many different kinds of scroll, many of which happen simultaneously. Zooms and pull-backs (scrolling three-dimensionally) are combined with

Figure 1.4 *Jacob Gilbreath,* Kinetic Typography, *2011. This piece depicts a single digital model. The camera pans through the model, as if approaching or withdrawing from typographic objects. The effect is a complex 3D scroll, in which the camera moves relative to a static arrangement. © Jacob Gilbreath.*

flat scrolls (horizontal, vertical, diagonal, and rotational). Nonetheless, such examples still do not exhibit true typographic kineticism. Though the camera moves, the typographic arrangement is stable. The layout—the relative position of words and letters—is fixed. Though the tracked camera creates motion, the typography itself is not dynamic.

Dynamic layout

When letters and words move independently of one another, typographic layout becomes dynamic. In *dynamic layout,* the relative distances between different typographic elements change. One word may move while another remains static, or letters may be repositioned within an arrangement. Compositions transform as elements realign. This invites the possibility of words and phrases being formed and re-formed on the screen.

Dynamic layout treats the space between letters and words as flexible. It assumes that there is no fixed spatial relationship between the forms on the screen. Composition fluctuates so that there is a continuous evolution of typographic layout. This elastic space allows individual letters to become disconnected from a word, or individual words to become disconnected from a sentence.

Although verbal units (letters and words) may be independent forms, they are generally interdependent in any given "chain" (Saussure, 1983 [1913] , p. 70). The alphabet consists of 26 characters that can be applied in different contexts to contribute to the various different meanings

of words within a language. Likewise, language consists of words that can be rearranged and reused in different contexts to contribute to the meaning of numerous different sentences. In semiotic terms, the meaning of a word is affected by the syntagm (context, or sentence) (ibid., pp. 126–7). Meaning can therefore be constructed or changed by moving units within a typographic arrangement.

Dynamic layout alters the arrangement of letters or words on the screen so as to create or change the typographic message (see Figure 8). When letters and words are separated from a composition, and move independently, they may each be subjected to a different kind of kineticism. This may involve the independent scrolling of a single letter, while other elements remain static, or different scrolling motions applied simultaneously to different elements within the composition. As a consequence of this motion, the typographic composition is rearranged.

This kind of *dynamic layout* must be set apart from *scrolling typography* for two reasons: firstly, it is not achievable by the motion of the camera alone, since letters and words move in relation

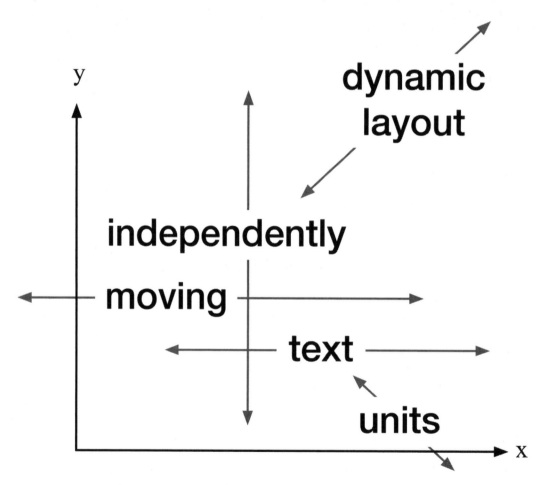

Figure 1.5 *In dynamic layout, words and letters move as independent units, so that the overall typographic composition may be rearranged.* © Barbara Brownie.

to each other as well as in relation to the frame of the screen; secondly, it requires different parts of the composition to behave in different ways at the same time. To alter the relationship between two elements, they cannot be subjected to the same motion. Rather, they must behave as independent units. This allows simultaneous events to occur in different regions of the screen.

Simultaneous events can create chaos, but more often, practitioners choose to use these events to guide the viewer through the text. It is often the case that the most complex or dominant motion is applied so as to draw attention to the next letter or word in a sequence, thereby aiding the reading process. While this occurs, other less significant motions can be used to remove words from the screen when they no longer form a necessary part of the composition. In this way, *dynamic layout* can be used to create a continual flow of narrative that originates from no particular point of origin.

David do van Minh offers an example of *dynamic layout* in his *Motion Typography (Les Voyages en Train Grand Corps Malade)* (see Figure 1.6). Here typographic elements change their location both in relation to the frame and "in relation to each other," so that the distances between forms (and hence, layout) is not fixed (Hillner, 2005, p. 166). In this animation, some phrases scroll while others rotate, resulting in constant change in the arrangement of the words on the screen. The behavior of these words is designed to facilitate reading. They appear on the screen at a pace that reflects reading speed. The most recent word is often the most active, allowing it to become dominant at the moment it is read by the viewer.

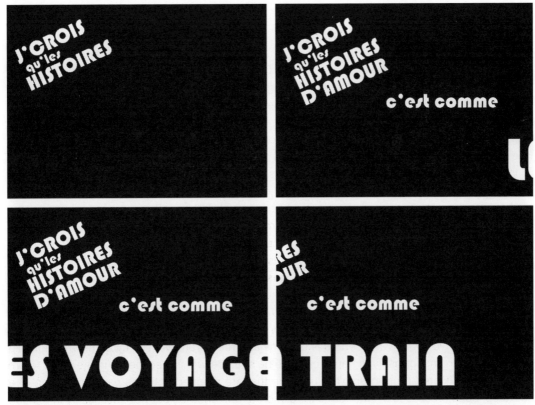

Figure 1.6 *David Do Van Minh,* Motion Typography (Les Voyages en Train Grand Corps Malade), *2006. In this example of* dynamic layout, *the relative positions of words change.* © David Do Van Minh.

The dynamic units may be smaller. Individual letters are separate units, and so can be moved independently of one another. The letter is an adaptable form, with potential for application in different contexts. An "a," for example, may serve a different purpose in "can" as in "can's." Anagrams demonstrate that a single set of letters can be rearranged into a variety of words, each with a different meaning. The alphabet, which contains only 26 letters, provides the component parts for every word in English and other languages. This creates potential for messages to be altered as letterforms are substituted for each other. If letterforms on a screen are treated as independently moving components that can be rearranged, the meaning of an on-screen message can be dynamically altered.

Dynamic layout, whether its moving components are whole words or individual letters, can be equated to a series of different compositions, presented in sequence, with journeys connecting one composition to the next. The most aesthetically pleasing dynamic compositions are those that treat every key frame as an independent work of typography, following the same rules of composition that would be applied in a static arrangement.[1] When each static composition is suitably styled and composed, it is likely that the whole dynamic piece will also convey the desired aesthetic. That is not to say that the dynamic connections between those compositions are not also important in conveying a sense of mood. The style of motion applied to moving words and letters also contributes to the overall effectiveness of the sequence.

Kinetic typography: Motion and change

The temporal events that have been described so far—*scrolling* and *dynamic layout*—feature motion that is a change in location. In these categories, objects are displaced from one location to another. Their position on the screen may change, and so too may their angle of rotation. Several theorists and commentators acknowledge that there may be "other kinds of change" (Lee et al., 2002, p. 81), that are unrelated to the location of a form on the screen. These other kinds of kineticism may happen in addition to, or instead of, displacement.

In the above examples, although there is substantial change, it is only the overall layout that is affected. In *scrolling typography* and *dynamic layout*, movement is directional: letters and words are kinetic only in so far as they are relocated from one place to another.

By affecting only the location of forms, *scrolling typography* and *dynamic layout* prioritize composition over the design and behavior of individual letterforms, making layout the focus of kineticism. These methods explore the relationship between the frame of the screen and the letters contained within it, as well as the relationship between letters or words within that frame.

Like maps, these forms of temporal typography rely on changing relationships "to situate," "to orient," and "to navigate" (Bogen et al., 2010, p. 67). In the first of these, the artifact situates one letter or word in relation to another, thereby forming a word or sentence. That situation can change in *dynamic layout*, when letters and words are free to remove, changing their relationship with the surrounding forms. Typography can also be situated within a scene, as in the *Panic Room* title sequence (Plate 2), using *scrolling* motions that are mapped onto the panning motion of a backdrop. Such processes situate forms in relation to one another, but not necessarily in relation to the audience.

Where there is the impression of 3D space, *scrolling* motion can imply relationships to the viewer. In this way, viewers are encouraged to spatially orient themselves in relation to, or within, the scene. This is particularly the case in interactive typographic scenes, when the user is able to control navigation through a scene. That navigation is virtual, presented, in veridical terms, as a changing relationship between the words and the frame of the screen. As words grow larger and approach the frame of the screen, viewers are given the impression that they are moving forwards through the virtual typographic landscape.

In all of these cases, kineticism is limited to directional motion (displacement). Letterforms are relocated rather than transformed. Priority is given to the relationship between letters, not the features or identity of each individual letter. Some theorists acknowledge that temporal media allow for "other temporal change" that cannot be described as motion (Lee et al., 2002, p. 81). This may be because there is an assumption that the properties of individual letterforms should remain constant, as they would in print. As the following chapters of this book demonstrate, this stability does not always exist in kinetic artifacts.

2

Global v. local events

Global displacement and local kineticism

Among some theorists, there is an assumption that "the *identity* of an object moving on the screen is constantly preserved" (Shaw and Ramachandran, 1982, p. 491). This in turn assumes that kineticism can affect the relationship between letters, but not the letters themselves. Many contemporary examples of temporal typography demonstrate that this is not the case. Although directional motion preserves the shape and identity of individual letters, it is not necessary for letterform to be preserved in this way. They may be mutated, fractured or changed in numerous other ways, leading to transformation within individual forms. That transformation can lead to a change in the shape and identity of a form.

In order to address the difference between motion and other kinds of kineticism, it is useful to begin by differentiating type design from typographic layout. In static typography, a distinction is made between the roles of the typographer and the type designer. Donaldson (2009) argues that a typeface is a "prefabricated" tool, developed by a type designer for use in multiple contexts. The typographer or graphic designer plays a secondary role, applying this pre-existing typeface in a new context. The different roles of typographer and type designer necessitate different priorities. In designing the shapes of individual letters, the type designer must be primarily concerned with the letterform itself. The typographer, however, as he or she lays letters alongside one another on a page, must be primarily concerned with the relationship between letters: their spacing, hierarchy, and so on. A typographer, therefore, is concerned with the global, and a type designer with the local. At a global level, there is an arrangement of typographic forms, as designed by the typographer, and at a local level there is a particular typeface, as created by the type designer.

Most previous research into temporal typography has focused on global elements, dealing with the presentation of letters rather than the local features of their design. This has led to the implicit assumption that temporal typography mostly concerns composition and motion rather than letterform creation and transformation. As Peter Cho (1997, p. 10) observes, existing texts on temporal typography tend to focus on changes in size, orientation, and position, assuming that forms, though in motion, remain "intact," thereby ignoring the fact that individual forms may be

manipulated. Many authors, such as Soo C. Hostetler (2006), do not make distinctions between forms which move (undergoing displacement: a change in location), and those which change in other ways.[1] This distinction is perhaps not made because it requires an additional distinction to be made: between global and local events.

Motion is, by and large, a global phenomenon, affecting the relationship between separate forms and the space they occupy. Those categories of temporal typography identified in Chapter 1 all exhibit global change. In temporal typography with only global change, letters, and words are displaced, but not fundamentally changed. Letterforms, and even whole words, remain intact. The location on screen may change, but the properties of individual letters do not. In *dynamic layout*, for example, the contents of the screen change as words move and composition is rearranged. Meanwhile, at a local level, the individual letterforms retain their defining characteristics throughout, including typeface, color, and alphabetic identity.

A prioritization of the global over the local may occur due to a feature of perception explored by David Navon, known as "global precedence." Navon (1977, p. 354) observes that "processing of a visual scene proceeds from ... global-to-local," so that the viewer is likely to apprehend "global features of a visual object ... before its local features." Navon argues that this is because knowledge about "general structure is more valuable than few isolated details" in understanding a picture or scene (ibid., p. 356). In written language, a letter acquires meaning by being placed alongside other letters, and so its position in a larger, global environment seems more meaningful than the letter alone. This tendency to favor the global may account for the number of texts that focus on global features of temporal and other on-screen typography, at the expense of the local (not least, Lee et al., 2002; Specht, 2000; Southall, 1993).

By prioritizing global over local, it is possible to neglect discussion of some of the most interesting new developments in temporal typography. This oversight needs to be addressed to account for the increasing number of artifacts that feature manipulation of individual letterforms. In these artifacts, local change can occur in addition to, or completely independently of, the kinds of global change outlined in Chapter 1.

Recent developments in temporal typography may be mapped onto the different practices of type design and typography that exist in print, and that have been outlined above. The field of type design is itself beginning to produce examples with temporal properties. When type design occurs for temporal environments, as in traditional, static type design, priority is given to the individual letter. Since the process of typeface design requires each character to be treated independently (prior to any application on page or screen), any temporal behaviors are necessarily local.

Though animated typefaces may be a recent phenomenon, their origins can be seen in a number of works, as in 1991 when, as Bachfischer and Robinson (2005) observe, Lucas de Groot took advantage of Adobe's *Multiple Master* tool, which enabled manipulation of typefaces. De Groot used the tool to "generate movement:" to morph "between character and graphic icon." Although Bachfischer and Robinson identify this example as important in the development of temporal typography as a whole (and in doing so sidestep the local/global distinction), the example can be used to demonstrate a connection between local change and the process of typeface design. De Groot's *Move Me MM* was not an animated typeface, but it did demonstrate how a typeface could be animated, thus paving the way for more recent innovations, such as Bruno Nadeau's *Complex Type*.

Lewis and Nadeau's (2009) paper, "Writing with Complex Type," discusses new alternatives to older typefaces, establishing as its focus new developments in fonts rather than the field of temporal typography. As a result, Lewis and Nadeau concern themselves explicitly with local kineticism: with "the letterform itself." The examples of recent typefaces described in the paper include some of Nadeau's own kinetic typefaces, many of which exhibit fluctuating contours or even more significant local change. In the *Hydre* typeface (2009, Figure 2.1), for example, Nadeau has created letterforms from independently moving particles, which, although loosely constrained within the shape of each letterform, have the freedom to move within and outside of each letter, with the result that contours are not fixed.

As with static typefaces, *Hydre* provides users with a pre-existing set of letterforms that can be used in multiple contexts. Users are free to arrange *Hydre* letterforms as they see fit, and to adjust the relationship between those forms, either within temporal typography (to create *dynamic layout*), or within a fixed composition. In all cases, since local kineticism is integral to each individual letterform, the artifact has a temporal dimension.

Local kineticism also appears in contexts where designers necessarily focus on individual, independent forms, rather than larger quantities of text. Local kineticism is ideal when the focus of an artifact is one or few letters, since it can bring a letterform to life without requiring that letter to be placed within the context of a word or sentence. Brand identities tend to contain a small quantity of text and therefore offer the possibility of exploring each form independently. It is perhaps for this reason that, in the field of temporal typography, the television ident has played a significant role in the development of local kineticism. An ident is a short sequence involving some treatment of the broadcaster's logo or other identifying image, usually broadcast between programmes. With the increasing number of television channels established in the late twentieth century, television idents became important tools of distinction and promotion. In the spirit of the medium in which they operated, television idents tended to contain motion graphics. Static logos were subjected to animation. Perhaps because the ident tends to display only a short name, or even a single digit (rather than the significant body of text that one would expect in a credit sequence), the focus is necessarily on one or few forms, and local properties arguably become more important. As a result, many television idents can be seen to exhibit change at a local level. Umeric's MTV ident (2010, Plate 3) contains only three letters, and so its potential treatment in *dynamic layout* is limited. In this and numerous other MTV idents, the designer focuses on manipulating the individual letters of the logo, predominantly the "M."

Elasticity or transformation

Letterforms that exhibit local change may be considered to be *elastic*. Their contours are not fixed, and so they are locally malleable. In Bruno Nadeau's *Hydre*, for example, the letter "g," though remaining constantly identifiable as a "g," does not always have the same shape. Its contours burst outwards, affecting its silhouette. This kind of change may be easily differentiated from global kineticism, in that it is not dependent on the changing location of the letterform. These letters change despite remaining fixed in a single location. Though global and local change are not

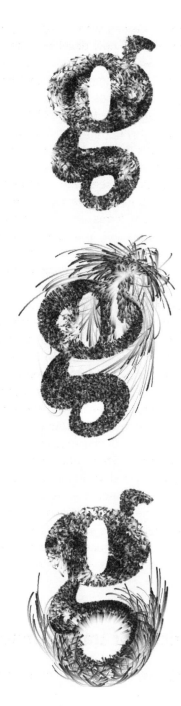

Figure 2.1 *Bruno Nadeau,* Hydre *(g), from* Complex Type, *2009. Kineticism is an integral feature of each letter of this typeface, rather than a feature of a particular work of typography which may be created subsequently. © Bruno Nadeau.*

mutually exclusive, they are not dependent on one another. A letter can change locally regardless of whether it is also moving around the screen.

There is a longstanding notion of the letter as a malleable form. Since experiments with the malleable typographic grid in the seventeenth-century creation of *Roman du Roi*, it has been common practice to distort typefaces to produce *italic* and **bold** versions. In designing their new typeface, and its various versions, the French *Académie des Sciences*, placed letterforms on a grid. They later created the slanted (italic, or "penché") version of *Romain du Roi*, by apparently "deforming" the grid (Andre and Girou, 1999, p. 10). This established the notion that a sloped letterform can be an alternative version of an existing upright, as opposed to an entirely separate typeface (Miller and Lupton, 1992, p. 21). Most significantly, this alternative version was achieved by treating the letter as a malleable shape. Slanted versions of *Romain du Roi* letterforms were achieved by tilting the vertical lines of the grid, and thus type could be considered, implicitly, and potentially, malleable. This ultimately introduced the notion that type, although static in print, has the potential to be manipulated. The notion of deforming a typographic character allows for three very important ideas for contemporary temporal typographers: firstly, that a single form can have multiple alternative states or appearances; secondly, that those different states may exist within the same object/space but at different times; and thirdly, that a form may be permanent without being fixed.

Through distortion, the contours of a letter may fluctuate, and so a letter may acquire different states. In print or in much temporal typography, letters are selected with a pre-existing state. So, the transition from one state to another is not visible. The different states of a typeface, including bold and italic, are predetermined. However, in the type designer's studio, the creation of these different states is a dynamic process, involving the manipulation of each letter so that it is stretched (for bold) or skewed (for italic). In kinetic typography, *elasticity* brings these and other manipulations to the audience.

Michael Flückiger and Nicolas Kunz's interactive typeface, LAIKA (2011), demonstrates how the process of distortion is made visible and temporal on the screen. Flückiger and Kunz have identified that, with new temporal technology, a typeface does not need to be "rigidly set" (Patterson, 2011). It can fluctuate between its various states, so that the viewer witnesses its transformation from upright to italic or bold. Flückiger and Kunz present LAIKA as an installation, in which audiences could move either their bodies or a set of controllers to watch the letterforms change between states.

Further examples show how this kind of manipulation of a letterform may be a temporal process. The *Soft Sketches* of Jason E. Lewis (2001) present letters and words that are "soft" and malleable. In *It's Alive*, Lewis depicts the word "pull" and subjects it to *elastic* behavior. The letters are stretched and distorted, so that the "ll" is elongated, and the baseline becomes curved. Though this distortion changes the shape of the word, it remains legible.

Elasticity may have a function beyond the distortion of letterforms. In some cases, the properties of the distortion become meaningful, communicating additional information. In some artifacts, *elasticity* is used to signify the presence of an invisible object. Certain distortions may imply that letterforms are moving across the surface of a shaped object or textured surface, without that object or surface being otherwise visible. For example, letterforms that bulge as they pass the middle of the screen, and are diminished at the edges, may appear to be scrolling across the surface of a sphere. The existence of a spherical form is indicated by the distortion of

the letterforms as they apparently pass over its imagined surface. This follows along the principles of concrete poetry, in which a form is only indicated by the silhouette of an arrangement of text.

In other cases, *elasticity* may be used to suggest that type is attached to a visible moving surface or object. This in turn suggests that the letterforms are located in the scene rather than overlaid. For example, a gently fluctuating curvature of contours may imply that letterforms are floating on the surface of rippling water. Such methods are becoming an increasingly common way of locating typographic elements within a scene, as evidenced by the availability of plug-ins and tutorials specifically designed for this purpose.[2] In these artifacts, the letters retain their identity, but their elasticity implies the presence of an additional form or object.

When specifically addressing local kineticism, there are further distinctions that must be made, largely involving the extent to which change affects the form of a character. In examples such as *Hydre* (Figure 2.1), letterforms are distorted, but retain their verbal identity; the "g" remains a "g," however distorted. In examples such as Umeric's MTV ident (Plate 3), the local change is so extreme that the identity of the form changes. It is initially perceived as a collection of abstract objects, but then appears to become an "M," having changed to such an extent that it loses its initial pictorial identity and adopts an alphabetic identity. There are other examples which exhibit this kind of severe local change, such as the animations of Nikita Pashenkov. Pashenkov, the creator of *Alphabot*, a virtual robot that may transform to take the shape of any letter of the alphabet, has produced interactive artifacts that could fall into this category of local kineticism. In animations of the *Alphabot*, letterforms are "malleable," capable of altering their form (TDC, 2001). This transformation is distinctly different to global change in location (or, "motion") and is more extreme than *elasticity*. It is a total change in the identity of the presented form. The "robot" transforms, becoming the letter "A," then the letter "B," and so on. Without changing location (i.e. without moving), it changes; it assumes a new identity. Pashenkov's letterforms transform, reconfiguring from one shape into another, each form presenting a different letter as it evolves over time. In both of these examples, the letters are not so much in motion as in flux. They transform rather than move.

Such works do not just present aesthetic change, but also transformation of meaning. Extreme change or "deformation" at a local level affects the identity, and so the meaning and nature of forms (Cho, 1997, p. 6). Change within individual letterforms can be so severe that the initial verbal identity is lost, and is replaced with an entirely new pictorial, abstract or verbal identity. It is this kind of local change that will be addressed in the following chapter.

3

Local kineticism and fluctuating identity

Fluid typography

When individual letterforms are not fixed, in location, shape, or identity, they can transform to the extent that they become something else. Previous texts have acknowledged that letters can be malleable, but few address the extent to which the contours of a letter may change, or the consequences of such change.[1] Peter Cho (1997, p. 10), whose work will be discussed in Chapter 4, describes how "malleable typography" may be deformed to the extent that it loses legibility, and "becomes no longer recognisable as a letter." He observes that, in some cases, forms may even "change shape and become a different letter" (ibid.).

The failure to differentiate between global and local kineticism (as outlined in Chapter 2) is perhaps responsible for the lack of discussion about the ways that local behaviors can affect the identity of individual letterforms. As Shaw and Ramachandran (1982, p. 491) incorrectly observe, "the *identity* of an object moving on the screen is constantly preserved." Letterforms, despite undergoing motion or change, are assumed to have a fixed linguistic identity, and to be permanently typographic. Contemporary artifacts show, however, that this is not the case. In examples such as those below, letters transform, abandoning their alphabetic identity in favor of another, or becoming typographic when they were initially presented as abstract, or pictorial. Such artifacts may not have previously been identified as representing a distinct category of typography because they are not consistently typographic. They blur the boundaries between type and image, being only temporarily typographic.

Since so few texts discuss the potential of kinetic typography to completely transform its shape and meaning, it is necessary to look outside of the field of kinetic typography for explanation and analysis. There is a distinct similarity between the holographic poems of Eduardo Kac and the events seen in some on-screen, kinetic typography. Teemu Ikonen (2003) identifies the letters in Kac's holopoems as "non-rigid objects" with a "dynamic grammar in which ... signs change their form." He observes that "transitional stages between recognisable letters" occur in both Kac's work and more recent on-screen kinetic typography, and begs that "the challenge ... be taken to develop a means of analysing and describing" this transition.

All of Kac's holopoems display one or more words in a hologram, so that they appear to "exhibit behavior" when the viewer moves within the space in front of the hologram (Kac, 1997). From 1986 onwards, Kac (1995, p. 31) began to explore the "possibility of a letter changing into an abstract color image and vice-versa." In these holograms, including *Havoc* (1992), *Astray in Deimos* (1992) and *Andromeda Souvenir* (1990), the motion of the viewer prompts apparent change in the holopoem. As viewers move around the gallery space in front of the poem, the shapes appear to change, so that the identity of the depicted forms appear to alter. Letters cease to be letters, changing their appearance so that they appear as objects or abstract shapes.

In *Andromeda Souvenir* (1990, Figure 3.1), as the viewer navigates around the hologram, a number of abstract polygonal objects appear to align to present the word "LIMBO" (ibid., p. 35). The relative position of the viewer causes those objects to appear to be arranged in different ways, and therefore by changing the relative locations of the viewer and objects (as when the viewer navigates around a holopoem) the objects can appear to align to construct a meaningful configuration. Kac's holographic forms appear to float within the real space between the viewer and the surface of the hologram. The letters of the word "LIMBO" are composed of apparently 3D objects which align to form letters when seen from a particular "viewing zone."

Kac (1997) describes his work as "fluid." A "fluid" sign, he tells us, "escap[es] the constancy of meaning a printed sign would have." The same description can be applied to digital, on-screen, fluid typography. Fluid signs can present multiple meanings. A fluid form evolves over time to the extent that its meaning also changes. A fluid sign is "not either one thing or another;" its form is constantly in flux, as is its identity (Kac, 1995, p. 45). A single form may be observed in one moment as having a verbal identity, and in another moment, once it has transformed, as presenting another identity. Though in typography we would normally expect form and identity to be inextricably linked, and fixed, here an additional identity is introduced without the introduction of an additional form.

Fluidity is a particular type of transformation that is so extreme that the affected form presents multiple identities over time. It may begin as a letter and then transform into an image, or vice versa; it may begin as one letter and transform into another; or it may transform between abstract and identifiable shapes. These alphabetic, pictorial or abstract identities are "poles" of a transformation (Kac, 1995, p. 46).

The poles of transformation appear in the moments at which the transforming object can most easily be identified as a particular letter, image or object. Many transforming forms have only two poles, fluctuating between two main identities. Others have multiple poles, and continue to transform from one thing into another, and another, and another. Ingo Italic's *Buchstabengewitter* (2012), for example, presents a single collection of straight lines, arranged so that their terminal points form the contours of a circle. The circle rotates, dragging these lines at varying paces, so that their arrangement is continuously changing. Where the lines overlap, they form the contours of each letter of the alphabet in turn. In this way, a single continuous transformation presents a total of 26 different alphabetic poles, and numerous abstract glyphs in between.

The means by which these identities emerge is not identical in all of Kac's works, nor in other examples of fluid typography. Screen-based fluid typography uses various behaviors to access the poles of transformation. Some employ *metamorphosis*, in which the contours of a letter fluctuate so severely that its identity changes; some feature *construction*, in which a letter is constructed from several parts that each have their own, separate identity; others exhibit *revelation*, in which

Figure 3.1 *Eduardo Kac, three views of* Andromeda Souvenir, *1990, digital hologram, 11.8 x 15.7 in. Kac's holographic forms appear to float within the real space between the viewer and the surface of the hologram. The letters of the word "LIMBO" are composed of apparently 3D objects which align to form letters when seen from the "viewing zone." Image courtesy: Julia Friedman and Eduardo Kac. © Eduardo Kac.*

external changes prompt the introduction of identities that already exist within an artifact but were initially hidden from view. These categories of fluidity are discussed in more detail below.

Metamorphosis

Of all the categories of fluidity, *metamorphosis* is the one that has been most widely discussed elsewhere. This is a behavior in which new identities can be introduced through the distortion of existing forms. Whole forms with flexible contours may be distorted so that the form is "reshaped" (Wolf, 2000, p. 83). This kind of reshaping can be distinguished from non-fluid changes such as *elasticity* (see Chapter 2) since it is so extreme that it generates new identities. Only when this kind of distortion occurs to the extent that the initial letter identity is abandoned, and a new identity is introduced, can it be described as fluid.

*Metamorphosi*s is a unique category of fluidity in the extent to which it has already been explored in existing texts. While the categories of *construction* and *revelation* are not adequately addressed in texts relating to any kind of artifact, particularly typography, metamorphosis is a well-established category and thoroughly explored elsewhere. There are numerous texts which discuss metamorphosis in the fields of multimedia and animation, as in the several texts collected in Vivian Sobchack's *Meta-Morphing: Visual Culture and the Culture of Quick Change*, and many more from other fields, particularly computer science and biology. Metamorphosis also appears frequently in fiction.[2] Although texts on the subject of metamorphosis generally do not discuss typographic forms, they often refer to the same technical behaviors that are applied in some fluid artifacts, and exhibit many of the key characteristics that one could expect to observe in morphing typography. Galin and Akkouche's (1996) text on "blob metamorphosis," for example, discusses processes that are very similar to those seen in the behaviors of morphing letterforms. Here, as in morphing typography, one form distorts, losing its initial identity and eventually adopting another. In the intermediate stages, the form takes on unfamiliar characteristics and, during these stages, it is difficult to attribute any particular identity to the form. Such examples reveal that local transformations, leading to the adoption of new identities, are acknowledged and understood by numerous practitioners and theorists in fields unrelated to typography.

Many examples of *metamorphosis* in fluid typography display characteristics that remind the viewer that *metamorphosis* is not a product of the digital age. Screen-based technologies (such as timelapse video) have enabled audiences to experience natural processes of growth, decay and other forms of transformation, at an accelerated rate. Sequences created using this technology accelerate a natural process so severely that it appears to become magical. Meanwhile, the abundance of these sequences in natural history film and television has suggested the myth that accelerated metamorphosis is found in nature. The fact that metamorphosis is experienced in nature is exploited in BB/Saunders' Channel Five ident, *Love* (2006, Figure 3.2), in which a human egg is fertilized, then divides into four separate cells. Each of these metamorphoses into a letter to spell the word "love."

BB/Saunders' *Love* ident introduces a feature that complicates *metamorphosis*, by involving forms which divide as well as distort. Many texts in the field of multimedia and animation which use the term "metamorphosis" assume the presence of two identities, expecting there to be

Figure 3.2 *BB/Saunders,* Love, *ident for Five, 2006. In this complex* metamorphosis, *forms mitoically divide as they morph. © Channel 5.*

two poles of transformation. In some cases, including Lazarus and Verrous (1998, p. 373), and Surakhsky et al. (2001, p. 29), they are explicit in this assumption. There is an initial identity, which is lost through metamorphosis, and eventually replaced by a second identity. It is often the case, however, that a single form can metamorphose into many different shapes.

Love aims to reflect, explicitly, the biological process of conception and mitosis. Biological metamorphosis is often seen as a "continuous deformation" (Gomes et al., 1999, p. 4), rather than a process of change from one "pole" to another (Kac, 1997). In digital metamorphosis, two poles are in most cases, defined by the designer, whereas the shapes of any forms which appear during the transformation are calculated by whichever software has been used for interpolation. During the intermediate stages, as Kac observes in his holopoetry, the form may only be recognizable as an abstract glyph, "with in-between meanings that are neither one thing or another." "The meanings of in-between configurations," Kac (1997) suggests, "can not be substituted by a verbal description, or by a synonym." As will be explored later, in Chapter 5, these unidentifiable in-between shapes are as vital as the identifiable identities that exist at the poles.

The consequence of *metamorphosis* is that the original identity must be sacrificed in order to allow for another to emerge. Unlike in *construction* (see the following section) where the identity of component parts can remain even after a new linguistic identity has been introduced, and unlike in *revelation* (see later in this chapter) where all identities are permanent, *metamorphosis* requires the loss of the initial identity. A single morphing form does not present several identities simultaneously. This fact sometimes becomes important in the meaning of the artifact. In Waber's *Argument* (see Chapter 9, Figure 9.1) the two words, "yes" and "no" are formed from a single elastic line. The line distorts to form each word sequentially. The words "yes" and "no" are binary opposites, and as such cannot co-exist. "Yes" must be sacrificed in order to achieve a "no," and vice versa. The *metamorphosis* in this artifact reminds us that some things are inherently incompatible. The introduction of a new identity requires the abandonment of another.

Despite the incompatibility of these opposing statements, "yes" and "no" are inherently connected. While the process itself "affirms a distance" (Bukataman, 2000, p. 240), Vivian Sobchack (2000, p. 139) observes that these metamorphoses "assert ... sameness across difference." Despite significant transformation there always tends to be "continuity," which binds the different identities of a metamorphosed subject (Olmstead, 1996, p. 196). In *Argument*, all identities are constructed from a string, and the visual characteristics of that string remain constant. The forms remain black and linear, helping to preserve the connection between the two words, "yes" and "no." Similar consistency in visual characteristics can be seen in other examples of morphing linguistic forms and objects, including BB/Saunders' *Love* (Figure 3.2).

Construction

Construction is the category of fluidity that most closely resembles the behavior seen in Kac's *Andromeda Souvenir* (1990, Figure 3.1). In *construction*, component parts collaborate in the construction of a whole letterform. The letter is conceived as a modular form, made from separate parts. Each part has its own identity, as an abstract or pictorial object. When the parts align, they introduce a single, shared identity—that of a letter.

The previous category of fluidity, *metamorphosis* (see above), requires the abandonment of the initial identity to enable the introduction of another. *Construction* does not require a total replacement of identities, rather a collaboration of multiple forms, each with their own identity, in the presentation of a more complex form. In this whole, while the parts retain their individual identities and appearance, the whole is more than the sum of its parts. The second identity can be a masquerade. The letterforms are a performance, a disguise which can be easily removed as component parts dissipate and return to their original, separate selves.

This characteristic of modular typography was established in print. In historical static typography and lettering, the role of any part of a modular letter is not necessarily fixed. Component parts are regarded as interchangeable. Their independent identities, therefore, are not tied to the identity of the whole configuration. In static examples such as Joseph Albers' *Stencil* (1925), or the De Stijl lettering of Bart van der Leck and Theo van Doesburg (1917), the same primitives serve several different functions, in several different letters (a single rectangle may be a stem, or, when

rotated, a crossbar). In fluid *construction*, component parts are actively seen to exchange one role for another. By being removed from one configuration and becoming part of an alternative configuration, a single shape or object may be seen to form part of several different identities.

There are two ways in which separate objects may come together to contribute to the *construction* of a letterform. The first involves *construction through motion of parts*, in which moving parts come into alignment to form the shape of a letter. These parts can be separately perceived as shapes or images, but when they move into a configuration they are perceived as being part of a greater whole. In some examples, such as Harm van den Dorpel's *Type Engine* (2005), these shapes are rearranged into several different configurations over time, so that each shape contributes to multiple different identities over time.

The second category of *construction* involves parts that do not independently move, but that are perceived as coming into alignment through parallax. Parallax is an optical illusion that occurs when objects, separated by distance, appear differently when viewed from a particular location. In *construction by parallax*, objects appear to align into a single form when viewed from a particular direction. This behavior is very similar to that seen in Kac's *Andromeda Souvenir*, in which the alignment of parts is caused by the viewer's navigation through space, rather than the movement of the hologram itself.

The diagrams below demonstrate the difference *between construction through motion of parts*, and *construction by parallax*. In Figure 3.3, an "A" is shown constructed from separately moving parts, which slide into alignment. Each part appears to be an abstract shape until it connects with others. In Figure 3.4, static shapes are positioned at different locations, at different distances from the viewer. When the viewer views these shapes from directly in front of the arrangement, a parallax occurs, and they appear to align to form a single letter.

In order for separate objects to be perceived as associated with one another, and therefore part of the same form, they must be similar and proximate. Similarity may be perceived in the characteristics of the shapes, or in the way that they move. In Jess Gorick's *The Letter "R"* (2009, Figure 3.5), fragments converge to form an "R." The fragments all share a similar style, resembling that of a hand-drawn illustration, and are similarly colored, with some pink surfaces and some green. This visual similarity prompts viewers to assume that the separate forms are somehow related. They also display similarity of movement, as

Figure 3.3 *Abstract polygons converge to form an "A" configuration in* construction through motion of parts. © *Barbara Brownie.*

Figure 3.4 *An "A" is formed in* construction by parallax. *Static shapes are shown from two different viewing angles, with one angle creating an apparent alignment that takes the form of the letter "A."* © Barbara Brownie.

they all float freely and then converge at similar speeds. The similarity in the appearance and movement of the objects causes the perception that, though separate, these objects are from the same origin or part of a group. The closer they move, the more related they become. Eventually, they are so closely proximate that they are assumed to be physically linked as a single object, the letter "R." The separate parts which come together to form this 3D "R" appear fractured and splintered, as if broken apart by some force of nature rather than the purposeful and calculated actions of the designer. This adds an additional curiosity: although the "R" is a regular and geometric form, its destruction (seen in reverse), is quite chaotic and unpredictable.

In this case, the fragmented parts appear to have been extracted from a single object, the "R." This perception is less likely when each of the component parts of a constructed form have a more distinct individual identity. MPC's Channel 4 idents, explored in Chapter 7, begin by introducing component parts as objects within a landscape. Each object appears to have an architectural identity, being part of a building or other urban construction. When parts have identities that are so different from the usual strokes of a letterform, it is difficult to predict that they may eventually serve some typographic purpose.

Construction can exploit negative as well as positive space. It is possible to construct a background, so that it leaves voids that are perceived as letters. This process can be identical to the construction of letters, with the simple difference that the letter is perceived outside of rather than within the configuration. Vincent Viriot's ident for Virgin 17 (2009, Plate 4) uses layered shapes to construct the negative space around a letter. Colored panels slide into place, aligning to present the contours of the word "pub." Here, it is the background that is modularly constructed, framing the spaces that can be read as letterforms. The letterforms themselves have the features of stencil lettering: the "P" and "B" contain protrusions from the contours instead of the usual

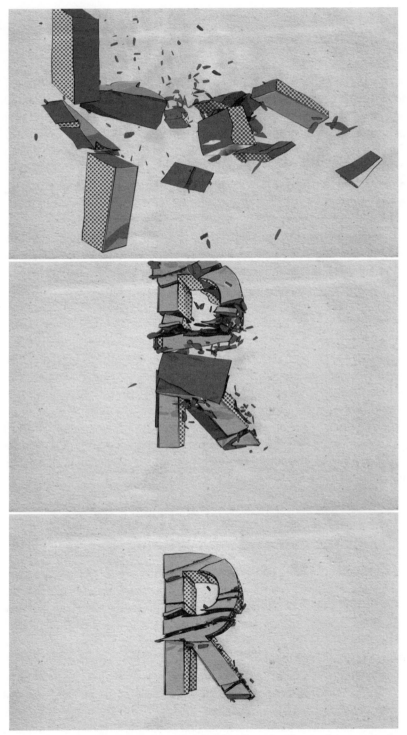

Figure 3.5 *Jess Gorick,* The Letter "R," *2009. Fragments come together to construct the letter "R," by converging towards the center of the screen. © Jess Gorick.*

holes. This feature is caused by necessity, as any hole would have to be formed from a shape that would be separate from the sliding panels. This is the inverse of modular lettering such as Joseph Albers' *Stencil*.

It is also possible to combine both positive and negative forms in *construction*, so that some of the component parts seem to become negative spaces when they come into alignment, while others are perceived as positive shapes. See, for example, Coleen Ellis' *ABSeeing* (2010, available at ABSeeing.com) which is directly inspired by the Gestalt notion of *figure/ground*. In this example, negative space is used to construct a series of 26 images, one for each letter of the alphabet. By creating each letter large enough to dissect its containing frame, thereby leaving a number of separate background spaces, Ellis presents a collection of abstract shapes. These shapes are then rearranged to form a scene or object. For the transformation of the letter "d" into a dog, for example, the negative form of the d's counter becomes the positive form of a dog's head, as it is repositioned in an arrangement alongside other shapes that had previously been read as background. The separate parts of the background move, rotate, and shrink, until they converge to form an image of the dog's body. In this example, therefore, there is not only *construction*, but also subtraction. In short, this example shows how abstract shapes can be perceived as voids (or, in typographic terms, "counters") if they come to rest at a particular location. Through this transformation, in which the same objects are used in the formation of "d" and a dog, a specific linguistic relationship is formed between the two poles of transformation.

This example shows how any kineticism can immediately disrupt the viewer's assumptions about the forms that are presented on screen. As soon as the motion occurs in Ellis' animation, there is a shift from figure to ground. The "d," initially perceived as a complete form, does not move as a whole. Instead, the parts of *ground* which surround it move independently of one another. This immediately destroys the perception of the white area as an alphabetic figure, prior-itizing the black and red areas and asserting their role as *figure* rather than *ground*. Ellis' project also provides an example of the construction in reverse. At the beginning of each sequence, the letterform is already visible. The letter, therefore, is not the destination of the transformation, rather the origin.

Revelation

The third main category of fluidity does not allow the audience to directly observe the creation of identities. Instead, it involves the revelation that those identities already exist, but have been previously hidden. Here, as in *construction* and *metamorphosis*, the nature of a scene defies audience expectations: forms which are initially assumed to have one identity are ultimately revealed to have another.

In *revelation*, alphabetic identities exist permanently in the objects on display, but they are not initially visible. The objects are therefore misinterpreted as being pictorial or abstract. It is only when the scene somehow changes that the true nature of the objects is revealed, and that the viewers encounter the alphabetic message. In this *revelation*, though the letter itself may not actually change, the viewer's initial assumptions about the meaning and nature of that form are forced to transform. The changes that occur in the artifact are independent of the letterform

itself: external forces change the perception of the letter, but do not actually transform the letter. These changes reveal new information about the nature of a scene, challenging the viewer's assessment of that scene by revealing previously hidden identities.

Like *construction*, *revelation* can occur in ways that exploit figure/ground relationships. Simple shifts in color or illumination can reveal forms hidden on a planar surface or within a 3D space. A verbal form can appear to emerge from a surface as when shifts in color or tone reveal a letter-shaped area as figure rather than ground. Color is used to distinguish figure from ground in Maxim Ivanof's ident for TV7 (2007, Plate 5). The ident begins with what appears to be an empty white screen. When colored shapes and signs begin to seep into the frame, it becomes evident that these colored shapes are contained within previously unseen contours. As more color is introduced, the contours are seen to belong to a figure "1." In this way, an area of the apparently empty ground is revealed as in fact being a numerical figure. Other figures continue to fill the screen in this way until the screen is so saturated that those areas that have formerly been perceived as figures become a new ground, and within them, new figures emerge.

In this and other examples, *revelation* occurs as a consequence of changes in color, which distinguish figure from ground. An equivalent kind of separation can occur through illumination, as a new light source can reveal a letter or object to be separate from a backdrop. *Revelation* can, therefore, occur *by color or illumination*. In order to differentiate figure from ground, a different color must be introduced to the letter than its background (as in Ivanof's example above). The same effect can be created when light is introduced, as illumination is commonly represented as a change in tone. Lighter or darker shades of a color signify an increase or decrease in the light that is cast on an object, and may also distinguish that object from other objects or backgrounds, that are exposed to a different intensity of light. The presence and location of light may also be indicated by shadow, and this too can enable the *revelation* of a letterform. If light is introduced so that it causes a letterform to cast a shadow, that letterform (as form) can be distinguished from other objects (as ground).

Shadows and illumination can also reveal additional information about the nature of a scene. In doing so, the shadow reveals more about the physical relationship between a letterform and the scene in which it is located. Depending on the shape of a shadow, it is perceived as being cast on different backdrops. If the shadow appears to accurately duplicate the letterform that has cast it, the letter is shown to be slightly raised from a surface on the same plane. If the shadow is skewed at an angle from the letterform, the letter is perceived to be standing upright on a surface. If the shadow is irregular, the presence of other objects or surfaces may also be perceived within the scene, following the principles of *elasticity* that were outlined in the previous chapter.

Revelation can also be an exploitation of the characteristics of 3D objects. In such cases, revelation occurs *by rotation or navigation*. Vincent Viriot's animation, *Evil/Love/Hate* (2008, Plate 6), presents a 3D virtual model which gradually reveals the presence of three different words within the same structure. From some viewing angles, the structure appears ambiguous, but from others it appears to be a word. The viewer follows a set, tracked path around the object, revealing all of its messages in sequence. As the film progresses, the camera navigates around the model to sequentially reveal the words "love," "hate," and "evil." None of its three linguistic identities can be viewed simultaneously, giving the impression that the meaning of the structure changes over time, as each word is displayed in sequence. Each object, being 3D, has several surfaces. Some of these surfaces are illuminated with an apparently blue light, others with a

pink light, and others are left unlit. Those surfaces which are unlit remain the same white as the backdrop, allowing for each object to appear noticeable when viewed from its colored/illuminated side, but to blend into the background when its undecorated surfaces are presented. As the camera swings in a loop around the arrangement of objects, each of the four structures presents, in turn, one of the four letters of each word. The differently colored surfaces help to differentiate between the different verbal identities, while the undecorated surfaces allow for an apparent reduction in the number of strokes when the same object must present, for example, the three strokes of an "A," in "hate" and then the single stroke of an "I" in "evil."

Viriot's animation is dependent on the fact that 3D objects have several different surfaces, each of which can be a different shape. The relationship between volume, space, and fluidity is explored in the next chapter.

All of the above categories share the same fundamental categories of fluidity, in that they present forms that are only fleetingly alphabetic. Viewers experience the emergence of letter-forms from pictorial or abstract scenes or objects, as the content of the screen changes. In some ways, these local fluid behaviors resemble the dynamism seen at a global level in other kinetic typography. What makes transformation at this local level so significant is that it transforms not only the message, but the very nature of the artifact. Fluid forms are only momentarily alphabetic, and so fluidity establishes a link between type and image that is not seen in global change (where letterforms are preserved).

A note on false fluidity

There are artifacts which may aim to present typographic transformations, which may be wrongly identified as *fluid*. Such artifacts imply transformation but are in fact complex examples of other categories of temporal typography. Artifacts may appear fluid when perceived subjectively, but when observed "veridically" (truthfully or objectively: Rock, 1975, p. 2), are shown to be remaining constant (and, therefore, *not* fluid). The identities of the characters may be perceived as changing, even though the forms themselves do not change.

Cinematic transitions may be applied in *serial presentation* to imply transformation where no fluidity actually occurs. In cinematic convention, a number of these transitions may imply transformation. A cross-dissolve between two similar scenes may, for example, represent a transformation from one to the next. In such examples, although no transformation is directly witnessed, the audience understands, according to cinematic convention, that a transformation has been implied. Kevin Fisher (2000, p. 118) cites, for example, the apparent transformation of *The Wolf Man* (George Wagner, 1941), as implied by a series of dissolves between a series of "static frames," sequentially revealing "the actor in various stages of make-up." In temporal typography, a sequence of static typographic arrangements may also involve such slow cinematic transitions, rather than sudden cuts. In such cases, one typographic arrangement does not transform into another; it is replaced by another. These examples cannot, therefore, be defined as fluid.

In some examples of 3D temporal typography, on-screen contours must necessarily transform in order to convey changes in distance and rotation. Since 3D objects are represented on a two-dimensional (2D) screen, 3D motion must be represented as 2D change. For example, a

shrinking letterform is perceived as receding away from the viewer. Similarly, volume may be suggested when a form distorts, implying "spatial rotation" (Woolman and Bellantoni, 2000, p. 64). This occurs because "perceived qualities … tend to remain constant, despite the fact that the proximal stimulus [or on-screen image] of objects is constantly changing" (Rock, 1975, p. 10). One example of this is "shape constancy": "an implicit assumption that objects are permanent" (ibid., pp. 69, 10). The Gestalt law of *Prägnanz* determines perception in such cases, suggesting that "there is a preference to perceive whichever outcome is the simplest" (ibid., p. 131). A constant shape is simpler (and more regular) than a fluctuating form, and therefore perceived as more likely. These objects are not perceived as transforming, but as moving and rotating. It is only when such objects rotate to present an alternative identity that these examples can be considered fluid.

Artifacts which could be described in the above terms cannot be classified as *fluid*, either because they do not exhibit transformation (merely imply it as a result of a cultural code), or they only exhibit transformation when viewed veridically, as a result of 3D representation on a 2D surface. Here, there can be a fine line between fluid and non-fluid artifacts, as an identical process may or may not result in an apparent change of identity. This is true of all forms of fluidity, where behaviors carried out to a limited extent may not yield new identities, but those same behaviors (as described in this chapter) may be applied to prompt more significant change, leading to new identities.

PART TWO

Issues in transforming typography

4

Illusory space: The page and screen as a virtual environment

Construction in three-dimensional space

Fluid behaviors may be divided into those that are possible in two-dimensions, and those that require three-dimensions. *Metamorphosis* and *construction through motion of parts* are both possible in two-dimensions as well as three-dimensions. *Construction by parallax* and *revelation*, however, can only occur if the fluid forms are 3D objects, or if they exist in a 3D space. *Construction by parallax* relies on a 3D space, while *revelation* exploits the features of 3D objects.

In *construction by parallax*, and in *revelation*, time and space are inseparable. The changes that occur over time are a consequence of motion through space, either of an object or of the viewpoint of the audience. These fluid behaviors are therefore dependent on the viewer's ability to understand the flat plane of the screen as depicting 3D space, and that that space may contain virtual 3D objects.

Three-dimensional letters are contradictory to the conventional or "customary" appearance of written or printed characters as 2D forms. As Skolos and Wedell (2006, p. 10) observe, "letter-forms themselves have no intrinsic third dimension."[1] Therefore, in order to perceive the presence of a letter that is constructed by parallax, a viewer must experience the apparent flattening of space. In this behavior, as parts of a letter configuration do not actually align, an illusion is created that the separate static parts are coming together. As the viewer's location relative to the forms changes, it appears that the relative positions of the forms also change. Forms that are arranged across virtual, environmental space, will, from most points-of-view, be perceived as separate forms.[2] However, from certain angles, the forms will be "imposed in front of [one] another so that only part of the more distant [form] is visible," or will appear to align, forming a single group (Rock, 1975, p. 83). Despite being spaced apart along all three axes, they create layers which may, from some viewing angles, appear to overlap or align. In this way, the multiple, separate forms may appear to be one, single form on a flat plane, because there is no longer any evidence for the space which separates them. This is an illusionistic compression of space (Damisch, 2002, p. 134).

An impression of compression of space is enhanced by the fact that the screen is itself 2D. The screen imitates a virtual 3D world, and viewers may be shown a representation of virtual

space, but ultimately the screen is a flat surface which does not allow "binocular disparity" that, in real-life environments, is a cue to the varying distances of objects (Rock, 1997, p. 371). For this reason, it is easier to assume relationships between objects spread across virtual space, or between the surfaces of a digital model, than it may be in real life. A parallax, for example, which may go unnoticed in reality, is more noticeable on screen, where all depth is compressed onto a single plane.

Flattening of space can be seen in animations of Hillner's *Cubico St.* (2003, see Plate 7), in which groups of 3D shapes revolve synchronously within a virtual 3D space until they align, presenting letterforms. In their initial rotational position, several planes are visible on each form. The viewer is made aware of these planes because each is shaded in a different tone (implying directional light on surfaces). When the forms have aligned, separate objects become component parts of each single letterform.

Notably, this font was developed in advance of plans for a real, 3D installation, in which these forms were translated into sculptural objects. In this proposed installation, large cubes containing abstract objects could be viewed from different angles. Audiences could access typographic meaning in the proposed installation by navigating around the cubes until they encounter an alignment of these abstract forms into recognizable letterforms.

In the digital-font version of *Cubico St.* (Plate 7), the three-dimensionality of the proposed objects is shown as the forms revolve on the screen. In this example, a particular feature of virtual 3D space—directional illumination—becomes important. When the shapes that form the letters of "cubico" are initially presented, their three-dimensionality is indicated by the presence of several different tones of orange, implying different degrees of illumination on different surfaces. In the final letterforms, only a single orange tone is presented, suggesting that only a single plane is visible, and that it faces directly forward. The arrangement of 3D shapes appears to have been flattened. In this way, there are two distinct shifts in the viewer's perception of the on-screen forms. Firstly, there is a shift from apparently 3D objects to 2D shapes, and simultaneously, a shift from abstract to verbal forms, belonging to two different paradigms. The first of these shifts—the flattening of space—enables the second—the appearance of letterforms.

This phenomenon of flattening is not always reliant on changes in illumination. Where light is ambient rather than directional, flattening of space can still occur. Objects can be perceived as existing on a single plane purely as a result of their apparent alignment. For *Fear*, a Channel Five ident by BB/Saunders (2006, Plate 8), and a series of other idents, designers working on behalf of Channel Five used *construction by parallax* to present atmospheric keywords to their audience. In *Fear* ethereal dots slowly drift through an empty corridor. Although the corridor is a 3D environment, the dots themselves are 2D, spaced along the x, y, and z axes. As the camera tracks through the corridor, the arrangement can be seen at an angle from which it momentarily appears to present the word "fear." The ethereal appearance of the dots is suggestive of a ghostly apparition, while the temporary and ephemeral nature of the text identity connotes an uncertainty and insecurity that is a feature of many horror films/programs. These dots are not only unfamiliar, but unexpected in the corridor setting, making it simpler to perceive them as part of familiar linguistic forms, understood as a graphic overlay of a kind that is common to television idents.

This ident presents alphabetic forms as if they were real-life objects, embedded in a live-action setting. One feature of a 3D space is that it is navigable: tracked motion through the space can replicate the experience of moving through a real-life environment. In presentations

of an apparently real-life environment, objects are expected to reliably behave as they do "in real life."[3] Indeed, every effort has been made to ensure that the component parts of the word "fear" are "plausible" as directly filmed objects.[4] The presentation of a graphical element (such as typography) within this space is therefore unexpected, belonging to a paradigm that is normally contained within a graphical environment, and its emergence from the scene is a spectacle.[5] It forces a sudden shift from an apparently environmental space, to a graphical space.

The introductory moments of this sequence establish presence in the everyday environment of a corridor. Objects within the environment, such as doors and windows, appear familiar and are expected to reliably behave as they do in everyday settings. The dots, despite their ethereal qualities, are also expected to behave like real-life objects, as they are so effectively integrated into the mundane scene. When these dots align and become typographic, they appear to break the rules of reality. The scene is abruptly cast out of reality, and suddenly becomes graphical. However, throughout this process, the separate dots retain their photorealistic appearance, "to ensure that they appear to be part of the environment" (Heusser et al., 2007). This heightens the spectacle, increasing the impression that the word "fear" is not simply an overlaid graphic, but a much more elaborate arrangement, comparable to a theatrical illusion.

In its use of 3D space, these kinds of fluid typography are remarkably similar to Eduardo Kac's holographic poetry (see Chapter 3). Viewers must move around the gallery space in front of Kac's holograms in order to witness the transformation of letters. In this way, the fluid transformation is dependent on real 3D space. Kac's writing briefly refers to "optical anamorphosis" in descriptions of his early holopoetry. The use of the term "anamorphosis" equates holopoetry to a significant field of art practice, dating back to elongated drawings which appear in Leonardo da Vinci's *Codex Atlanticus* (c. 1485), but more commonly identified in Hans Holbein's *The Ambassadors* (1533) (Tessauro, 2004, p. 97). When da Vinci's sketches "are looked at frontally, a regular progressive distortion … makes their recognition difficult. However, if one shifts one's position, closes one eye and looks at the drawings … from a sharp angle on the right side of them, the images recover their normal proportions. Unexpectedly, an eye and a baby's face seem to lift up from the surface" (ibid.). In Holbein's *The Ambassadors*, a strange figure appears towards the bottom of the painting which can be identified as a skull only when viewed from a "specific vantage point" (ibid., p. 99). Possible connections between lettering and anamorphosis can be observed in Lucas Brunn's *Praxis Perspectivae* (1615), a collection of images of objects viewed from unlikely angles, including a number of 3D letters (plates available in Massin, 1970, pp. 20–1). Though this history is not acknowledged by Kac himself, his one-time use of the term "anamorphosis" indicates that holopoetry may draw upon a history of practice that functions in a similar way.[6] Holopoetry, like anamorphosis, "will change as it is viewed from different perspectives:" it introduces new meanings, in the form of new identities, in response to changes in the viewer's location (Kac, 1995, p. 30).

Hubert Damisch (2002, p. 134) describes in anamorphosis the emergence of a "secret object," when the viewer "adopts the appropriate point of view." His use of the term "secret" suggests that the viewer who can experience the hidden subject is privileged. There is a sense that she is honored to encounter this subject, and to be able to uncover/expose its true identity. He further proposes that anamorphosis "implie[s] being shown an example of spectacular coincidence between the viewing point and the vanishing point" (ibid., p. 284). In referring to the experience as apparently one of "coincidence," John V. Kulvicki (2006, p. 188) also implies that the viewer is in

a privileged position: that she may feel lucky to have encountered such a phenomenon. Kulvicki's description draws attention to the fact that this experience is fleeting; that it may easily be lost. In turn, this implies that the moment of recognition should be a moment to be treasured. This observation draws attention to a third similarity between anamorphosis in paintings and in fluid holopoems. In both cases, the viewer may only view the recognizable identity from a specific, or privileged, location. Kac (1997) describes this privileged position as a "viewing zone."

When 3D space is navigable, as in virtual reality environments, there is no guarantee that viewers will observe a formation of objects from the correct "viewing zone." If given total freedom to navigate through virtual space, an alignment of objects through parallax may never occur, causing the viewer to miss the typographic message hidden in a scene. It is for this reason that *construction by parallax* is better suited to animations which follow a designated path.

However, there is a sense of satisfaction gained from the feeling that the parallax has been found serendipitously, so any predefined path must somehow preserve a sense of being unplanned. The sense of spectacular coincidence can be reinforced by placing cues in the scene that resemble a real-life environment. The more closely the scene resembles a real-life environment, the more the alignment of forms will appear to be coincidental. As shown in Channel Five's *Fear* ident (Plate 8), the tracked motion of a camera can be presented as a substitute for viewer navigation. If the camera has been positioned at about the same height as a human head, its artificial viewpoint will appear to resemble the viewer's natural point-of-view. This reinforces the sense of realism, and hence the sense of coincidence.

Revelation in three-dimensional objects

Letters in virtual, 3D spaces can assume "architectural" qualities (Miller, 1996, p. 2). They are no longer perceived as flat glyphs, but as tangible objects, often assumed to have adopted all the qualities one would normally associate with the 3D objects encountered in real-life space. One expects a virtual 3D letterform to present different faces when viewed from different angles, and that these alternative views may be accessed either by navigation around the object, or by movement and rotation of the object itself. This provides the possibility of concealing and revealing surfaces.

In his study of "dimensional typography," Miller (1996, p. 3), observes that "among the ways in which letters have been rendered dimensional, extrusion is probably the most prevalent." Three-dimensional letterforms existed as static typefaces long before the introduction of screen-based technologies.[7] These static, printed impressions of 3D objects depict only one of many possible angles of presentation. A 3D letter tends to be presented with its front face facing forward, so that the letter can be easily read. However, 3D objects have multiple surfaces, and typographers have typically neglected to exploit the alternative faces of 3D letters.

A real-world 3D letter may be approached from different directions. Only when it is directly approached from the front will the object clearly resemble a letter. From other viewpoints, the letter may resemble an abstract shape. The diagram below (Figure 4.1) shows a 3D "B" approached from different angles. When approached from the side, it resembles a flat, rectangular shape, with no indication that it may be a letter.

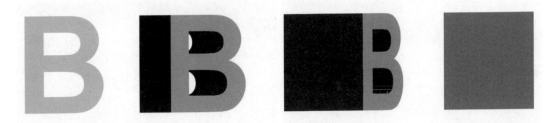

Figure 4.1 *An extruded "B" shown from four different angles. When approached from the side, the object resembles a rectangular plane, and the alphabetic identity of the object is hidden. © Barbara Brownie.*

On a flat screen, it is possible to select the angle of rotation at which objects are presented to the viewer. In this way, it is possible to conceal the true nature of an object, and then reveal it later by revolving the object to present a more meaningful face. It is in this way that *revelation* exploits the properties of 3D letters to make it appear as though the identify of an object has changed over time.

The possible ambiguity presented when an extruded letter is presented at an unconventional angle is demonstrated in another of Peter Cho's *Letterscapes*. Cho's interactive animation presents a wireframe "M" object (Figure 4.2). At some viewing points, the object looks abstract, and at others, it can be identified as a letter. When the user's cursor is located to the sides of the screen, the "M" is rotated and brought forward, so that the shape appears ambiguous or abstract: the screen shows an apparently meaningless arrangement of diagonal white lines and yellow polygons. The "M" identity is only revealed when the cursor moves towards the center of the screen, and the "M" recedes and revolves to present its front face.

In Cho's *Letterscapes (M)*, there seems to occur a transition from one kind of object to another. Initially, the object appears to be pictorial. However, until the alphabetic identity is revealed, it is unclear what the object may represent (if anything at all). Even before the letter is revealed, there is ambiguity. When the "M" is initially presented, although it does not yet look typographic, it also does not resemble any other familiar object. Its identity appears uncertain, or incomplete, ensuring the anticipation that more visual information will be revealed. The viewer seeks out meaning in the form, and is thereby motivated to continue moving the cursor until the entire shape of the letter "M" is visible.

Given that each face of a 3D object may have a different shape, and thereby a different identity, it is possible to contain many different meanings within a single object. For example, a single object may present the one word when viewed from the front, and an entirely different word when viewed from the side. A viewer approaching the object from the front would see the first word, while another viewer approaching from the side would see the second. Their reading experiences would be contradictory, but both would be correct.

In this way, it is possible for a single object to contain many different messages and meanings. As with all *fluid* type, there is inconsistency between the number of perceived identities, and the number of objects that are present. There may be one, single, 3D object, but multiple messages, each visible from a different viewing angle. Those different meanings can be revealed over time as the viewer is granted access to different viewing angles. If the viewer is initially shown only

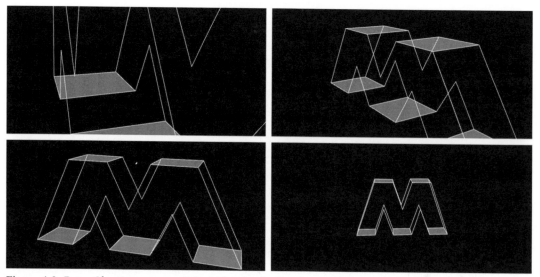

Figure 4.2 *Peter Cho,* Letterscapes (M), *2005. In the first frame of this sequence, an apparently abstract arrangement is shown. By pulling back from this object, the viewer can reveal its verbal identity.* © *Peter Cho.*

one surface, only one letter or word will be visible. If the object is then rotated on the screen, revealing sight of another surface, an additional meaning will be revealed. This is the process that can be seen in Kyle Cooper's title sequence for *True Lies* (1994, see Chapter 8), in which the word "true" is presented in 3D letters. The letters revolve, revealing the word "lies" carved as voids into the sides of the letters. These two contradictory messages are contained within the same set of objects, reinforcing the inherent connection between the concepts of truth and lying.

Similarly combined letters appear in Zach Lieberman's *Intersection* (2001, Figure 4.3). With his interactive animation Lieberman aims to create, in three dimensions, combinations of existing letterforms which yield "hybrid letterforms" and "new shapes" (Lieberman, 2001). Users are able to input up to three letters, leading to the generation of a 3D object constructed of cubes. Beginning with a large cube, the programme removes smaller cubes until the faces present all of the user's chosen letters, leading to a modular shape, with surfaces that resemble pixelated letterforms. Those surfaces that do not present letterforms, present "hybrid shapes," combining the reverse and side faces of the present letters. The user may drag the shape within 3D space to view alternative surfaces, creating the temporal experience of a revolving object which presents a sequence of multiple verbal and abstract identities.

Although *Intersection* attempts to generate this object from a combination of all the user's chosen letters, it reveals the difficulty of combining multiple letters within a single object. It is effective at combining two letters, able to present them either on opposite or neighboring sides, depending on the compatibility of strokes. However, difficulties arise when a third letter is introduced. The programme finds it impossible, for example, to generate a form that includes "E, 'C' and 'H,' since the central stroke of the 'E'" interferes with the shapes of other letters. The programme is forced to compensate by rendering the stroke partially. This provides evidence that, through *revelation by rotation*, the number of possible identities is limited. Since all identities must exist simultaneously, the number of possible identities is restricted by the number of surfaces

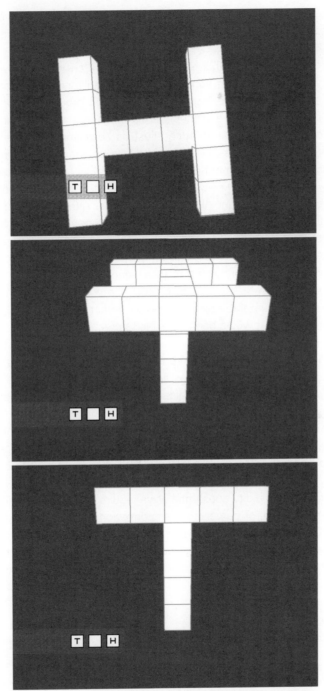

Figure 4.3 *"H" and "T" presented in Zach Lieberman's* Intersection, 2001. *In this interactive piece, a 3D object presents a hybrid of two or three letters, selected by the user. The user may revolve the object to view its various surfaces. Here, "H" and "T" are shown as a combined object, with a "T" visible from the front, "H" visible from the top, and other viewing angles showing a fusion of both letters. © Zach Lieberman.*

that exist within that particular object. When objects contain voids, through which the viewer can see alternative faces, as in *Intersection*, the inclusion of a high number of identities becomes even more problematic.

As observed at the beginning of this chapter, 3D objects are often shown to have volume by the varying illumination of different surfaces. This varying illumination can be represented as variation in color or tone on different surfaces of an object, or through the appearance or change of shadows. This illumination can be exploited just as much as the structural properties of a 3D object in order to conceal and reveal identities (just as color shifts aid the fluidity in Hillner's *Cubico St.*, see Plate 7). Peter Cho's *Letterscapes (H)* (2005, Figure 4.4) depicts an ambiguous 3D object. In response to the movement of the cursor, the object is temporarily illuminated from different directions, causing various color shifts. When light is cast from some directions, the object appears to be an arrangement of four tall polygons. Alternative lighting reveals several crossbars, joining the polygons and suggesting the presence of one or two 3D "H"-shaped objects. Even once these typographic identities have been revealed, the nature and position of the object remains uncertain, as Cho uses shifts in tone and color to create optical illusions, causing the surface of each letter to apparently shift to a new angle and location.

Letterscapes (H) presents an "impossible object." "Impossible objects" are 2D depictions which contain cues that suggest three-dimensionality but that are misapplied, thereby inspiring a single overall interpretation that would be impossible to create as a real object (see, for example, the Penrose triangle) (Fink, 1991). Such drawings are "interpreted as representing objects, but the objects represented could not be constructed because the spatial constraints of the environment have been contravened" (ibid.). These images appear to obey rules of three-dimensional repre-sentation "in local regions but defy them globally … This creates the impossibility when an interpretation of the whole figure is attempted" (ibid.). In any single frame of *Letterscapes (H)* the object does not necessarily appear to be impossible: many frames present a feasible, 3D "H" object. The object is only revealed as impossible over time; as user interaction reveals identities that are incompatible. It becomes clear over time that the object presented at any one time cannot conceivably exist alongside those presented at other times.

Cho's work illustrates that fluidity does not always require the actual transformation of a letter, and may describe an apparent, or perceived, transformation prompted by external changes. The alphabetic nature of an object may be revealed through changes to the direction or quantity of light, rather than changes that directly involve the letter itself. Transformation of surroundings can be as effective as transformation of a subject in introducing new meanings to the artifact.

Figure 4.4 *Peter Cho*, Letterscapes (H), *2005. Here,* Color shift *implies illumination of alternative surfaces, with different shifts appearing to reveal contradictory properties of the form.* © *Peter Cho.*

5

Legibility and asemisis in fluid typography

Legibility at the poles of transformation

There has been extensive discourse in the field of typography concentrating on legibility, punctuated in the late 1920s by the prioritization of legibility in Jan Tschichold's Modernist manifesto, *The New Typography* (1998 [1928]), and Beatrice Warde's *Crystal Goblet* (1930). The issue of legibility again became a popular topic of debate in the 1990s, following David Carson's questioning of the communicative value of legibility when compared to the other expressive possibilities of typography (Pipes, 2005, p. 168). One may expect, therefore, discussions of any new typographic medium to inevitably turn to the question of legibility.

When a form is in flux, as it is in *fluid typography*, its legibility fluctuates. Any letterform which undergoes change will become easier or more difficult to read as its contours evolve. Therefore, legibility in fluid typography is not a permanent state, but a process. On the few occasions when Eduardo Kac (1995, pp. 60, 35) references legibility directly in relation to his holographic poetry, his discussion focuses on the process of "becoming illegible," rather than the state of legibility. He draws attention to the relationship between the poles of transformation exhibited in his work, identifying them as the most legible stage in the transformation. The process of becoming illegible is also discussed by Matthias Hillner (2006, p. 4), who observes that, in his "virtual typography," there are "variable levels of legibility."

At phases within the transformation, a fluid form can be identified as typographic or alphabetic. It is only in these phases that legibility is a concern. At other moments in the transformation, fluid forms not only cease to be legible, but cease to be recognizable even as a vaguely linguistic form. So, as fluid forms transform from image to text, the question of whether text is legible becomes a question of whether forms are "text" at all (Hillner, 2009). The issue of specific letter recognition becomes less important than the wider issue of paradigm recognition: when a form has not simply been selected from a collection of 26 letters, but could be one of any number of signs from any number of paradigms.

During transformation, when a new identity is adopted by a fluid form, the semiotic notion of paradigm becomes important. Semiotician Ferdinand de Saussure introduced the "systems"

within which signs are categorized. The sign is the "basic unit" of any "language," ranging from words to military signals, and it is within the context of this language that the sign is understood (Rose, 2007, p. 79; Saussure, 1983 [1913], p. 15). Saussure viewed signs in relation to others, in the context, and in the same wider system. He identified "associative" relations (more commonly, "paradigmatic" relations) with other signs which could have been used in the same context (ibid., p. 123). These alternative signs are vertically located within the same "paradigm" (set of signs belonging to the same category) (Hawkes, 1977, p, 26). The context—in linguistics, the sentence—in which the sign appears, Saussure describes as the "syntagm." Saussure's text describes the meaning of signs as being affected by both syntagmatic and paradigmatic relations, and in doing so assumes that the sign appears alongside other signs from the same *langue*.

The two broad paradigms which are of most significance to the interpretation of fluid typography are those of verbal character and image. Reflecting Saussure's experiences, it is frequently the case that signs are seen alongside others from the same paradigm. Letters, for example, frequently appear alongside one another in words, and words frequently appear alongside one another in a sentence. More recent semioticians have addressed this assumption by exploring the juxtaposition of signs from multiple paradigms. Social semiotician Roland Barthes, and media semiotician Jonathan Bignell, discuss signs which exist alongside those from other paradigms. Bignell (2002, p. 34) observes how, in advertising, verbal and pictorial signs are juxtaposed to create a correlation between the meaning of the two. More specifically, Barthes (1977 [1964], p. 40) observes "anchorage," in which juxtaposed "text *directs* the reader through the signifieds of the image, causing him to avoid some and receive others." By anchoring a sign, it is possible to establish a "preferred reading" (Hall, 1980).

In much typography or concrete poetry, and even more so in fluid typography, signs transcend paradigmatic boundaries. A fluctuating letterform has features which locate it in several different paradigms, and that emerge over time. A fluid sign cannot, therefore, be located within one single paradigm. A fluid sign is, in semiotic terms, sometimes "arbitrary" and at other times "iconic" (Saussure, 1983 [1913], p. 67; Barthes, 1977 [1961], p. 25). Furthermore, it undergoes transition between these categories, at which time it cannot be classified wholly as either. At one pole of transformation, a fluid sign may be an arbitrary sign (a legible letterform), and as it approaches that pole it may become steadily more legible. At another pole, the form may be pictorial or "iconic," having become steadily less legible to the point it loses any signifiers of written language. In this way, a fluid form travels through variable levels of legibility, until it ceases to be in any way alphabetic. As a consequence, the question of legibility becomes irrelevant. The issue of letter recognition is overshadowed by the issue of paradigm recognition, as the viewer is asked to identify whether the form is verbal, pictorial, or abstract.

Any discussion on legibility assumes that the viewer is acting as reader, and that she has been presented with the challenge of deciphering a letter. In those moments when a fluid form is not alphabetic, the viewer must understand it pictorially rather than seek to read it verbally. When there is no letter, rather an image or abstract shape, there is no challenge to engage in verbal reading, and so no question of legibility. Hillner (2006, p. 4) suggests, therefore, that the issue of legibility is less important than the question of whether forms may be recognized as having any verbal signification, and in so doing implies that to discuss issues of legibility would be to oversimplify the events that occur in transforming verbal signs. Issues of legibility therefore become overshadowed by issues of temporality, and entwined with the relationship between word and image.

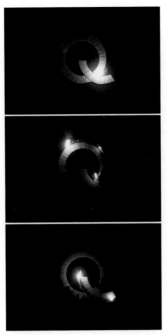

Plate 1 Dan Pedley, Q Fire, 2013. This directly filmed sequence demonstrates that temporal typography does not have to be generated digitally. Indeed, the irregularity and unpredictability of the hand-made often adds potential for expression. © Dan Pedley. www.quintusproductions.com

Plate 2 Picture Mill, opening credits for Panic Room, *2002 (Sony Pictures). In this sequence, the scrolling motion of the typography is mapped onto the panning of the camera across a city skyline. This creates the impression that the typography is embedded into the scene. The effect is enhanced by the 3D rendering of the letterforms, which causes them to resemble real objects. © Sony Pictures.*

Plate 3 Ash Bollard/Umeric, MTV Organic, 2010. This MTV ident presents change at a local level. The band logo constructed through the motion and expansion of abstract parts. © Ash Bollard.

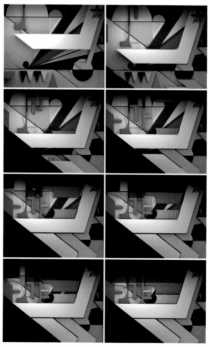

Plate 4 Vincent Viriot, Virgin 17 Ident, 2009. The word "PUB" is constructed as surrounding segments of the background rearrange to form a negative space for each letterform. © Vincent Viriot.

Plate 5 *Maxim Ivanof, TV7 ident, 2007. The contours of the number "1" are revealed as the figure fills with colored forms. These colors differentiate the number (the figure) from its white backdrop (the ground).* © Maxim Ivanof.

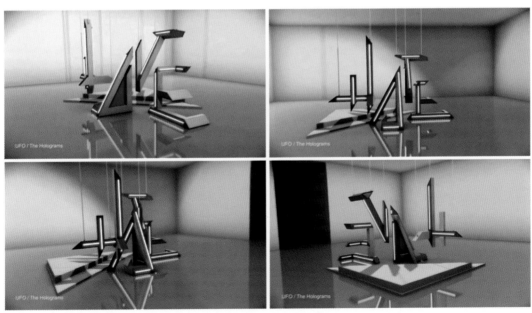

Plate 6 *Vincent Viriot, Evil/Love/Hate, 2008. Three words—"love," "hate" and "evil"—are revealed over time within a single 3D arrangement as a tracked camera navigates around it to reveal each word in turn.* © Vincent Viriot.

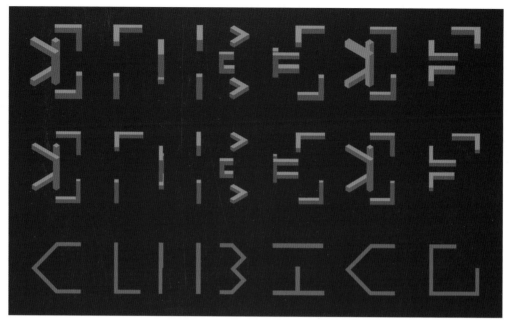

Plate 7 Matthias Hillner, Studio for Virtual Typography, Cubico St. "virtual" font, 2003. Abstract 3D objects revolve until they appear to come into alignment to construct letterforms. As they align, there is an apparent flattening of space which allows the viewer to perceive flat forms rather than the 3D objects that are initially presented. © Matthias Hillner.

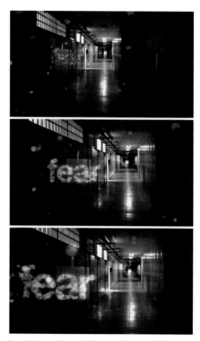

Plate 8 BB/Saunders, Fear, ident for Channel 5, 2006. Ethereal floating dots appear to align to present the word "fear" as a tracked camera navigates down a corridor. The dots appear embedded in the live-action footage, transforming the corridor from a pictorial to a graphical space. © Channel 5.

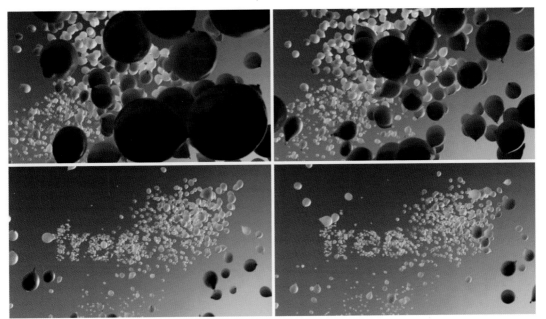

Plate 9 BB/Saunders, Free, 2006. In this ident for Channel 5, balloons float upwards into the sky and align to form the word "free." The precise meaning of the word "free" in this context is alluded to by the way in which it is constructed, and the nature of its component parts. © Channel 5.

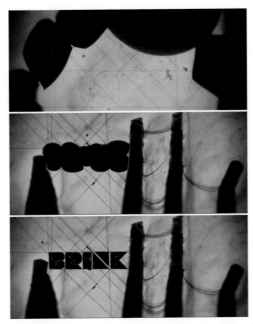

Plate 10 Emrah Gonulkirmaz, Brink, 2012. In this morphing lettering, five dark bubbles transform into the letters of the word, "brink." The regular and linear arrangement of similarly sized forms foreshadows the emergence of lettering, thereby preparing the viewer to become a reader. © Emrah Gonulkirmaz. www.emrahgonulkirmaz.com

Plate 11 *"Font" by Sylvia. The contours of the letterforms in this reactive typography fluctuate and vibrate as the user moves the cursor around the screen. The intensity of the fluctuation increases as the cursor increases its distance from the words, rendering them illegible. In this way, the words remain legible only when the reader is looking directly at them. Licensed under Creative Commons Attribution-Share Alike 3.0 and GNU GPL license. Work: http://openprocessing.org/visuals/?visualID= 9957 License: http://creativecommons.org/licenses/by-sa/3.0/ http://creativecommons.org/licenses/GPL/2.0/*

Plate 12 *Paul Hoppe, generative branding for the Exploratorium, 2011. Hoppe's generative letterforms are constantly in flux, but can be fixed at any time to create a static typeface for printed branding materials. Where the branding appears in temporal environments, such as on the website, it is constantly evolving. © Paul Hoppe. www.paulhoppedesign.com*

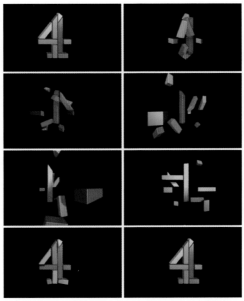

Plate 13 Martin Lambie Nairn, Round and Back, *Channel 4 ident, 1982. In this, Lambie Nairn's first Channel 4 ident, the figure "4" breaks apart into colored polygons, which are flung outwards and trapped in a vortex created by the revolving central column of the upward stroke. The polygons are then pulled back towards the center of the vortex, and return to their original positions in the "4" configuration. © Channel 4.*

Plate 14 MPC, Tokyo, Channel 4 ident, 2006. In MPC's idents, the "4" is constructed from apparently environmental objects. These objects appear to be part of the landscape until they apparently align to construct the "4." © Channel 4.*

Plate 15 MPC, Sky 1, 2, and 3 Boxes idents, 2008. For Sky 1, solid fragments escape from a box and are arranged like pieces of a puzzle to construct a large "1" object. For Sky 2, an identical scene depicts the same sequence of events, repeated with a liquid instead of solid substance. For Sky 3, the material from which the numerical ident is constructed is substituted for particles. © *BskyB.*

Plate 16 Alexey Devyanin and Nick Luchkiv, Field, *2009. In this animation, an abstract object is constructed by the rearrangement of moving shards, exhibiting a similar process to the* construction through motion of parts *that has been identified in this book.* © *Alexey Devyanin and Nick Luchkiv.*

Although legibility is only temporarily or partially significant, the process of reading is vital in the perception of fluid typography. Fluid transformation forces viewers to seek out meaning in new ways. Rather than simply being presented with a legible or illegible form as in print, the viewer of fluid typography must search for alphabetic forms within a more complex scene, or resolve a complex arrangement in a way that it may be perceived as alphabetic; this access to a verbal resolution is only permitted at certain times within the transformation. Reading fluid typography is, in this way, as much about locating a letter as identifying its meaning.

In many ways, the viewer of kinetic typography, particularly fluid typography, is a "spectator" rather than a "reader" (Kac, 1995, p. 2). Though reading is possible, and usually expected, the ways in which that reading becomes possible is often more interesting or more meaningful than the verbal content of the text. Arguably this is true of many examples of kinetic typography. Film title sequences, for example, are often watched but not read.[1] Their value in establishing mood is often more important than the factual information that they provide about the cast and crew of a production. This is true even of typographic elements, which can express the tone, themes, and genre of a film through design and behavior. Arguably, this visual information is more relevant to the viewing experience than the verbal meaning, which merely provides facts about its production.[2]

From such observations, it could be concluded that the verbal signification of a word is unimportant in credit sequences, or in some other examples of kinetic typography. However, the presence of words provides evidence to the contrary. If particular words have been purposefully selected by the creator of an artifact, it follows that their meaning must be significant. In his first holopoem, *Holo/Olho* (1983), Kac featured the word "olho" (Portuguese for "eye"). The choice of word drew attention to the fact that this first holopoem was intended as a "manifesto for a new way of seeing" (Kac, 1995, p. 94). It is not the case, therefore, that Kac's holopoems attempt to eliminate or evade verbal signification, simply that they prioritize other features that exist in addition to, or as an extension of, verbal meaning. In Kac's terms, a holopoem does not avoid, but rather "surpasses" a "dictionary definition" of the featured word.

A temporal relationship between word and image

As they fluctuate between word and image, fluid forms do not become meaningless. Despite being only temporarily alphabetic, fluid signs are also significant in their non-verbal expression. Their meaning alters as the language by which they communicate changes from text to image, and both the verbal and pictorial image are expressive. The multiple identities and multiple meanings are bound up in the same form, and so the relationship between them is also meaningful.

The relationship between verbal and non-verbal phases is vital in making fluid typography more significant than its static cousin. In Kac's (1995, pp. 30–1) writing, the "emphasis is on the passage from the poetic to the pictorial and vice versa," or from "the verbal code (the word) to the visual code (the image)." The fluid signs that he identifies in his holopoems "blur the frontier between words and images" (Kac, 1995, p. 57). His holopoems are not the first artifacts to challenge the boundary between verbal and pictorial forms. He acknowledges a "long tradition of verbal-pictorial synthesis" in, for example, concrete poetry, where Kac (ibid., pp. 40, 43) identifies "tension

Figure 5.1 *A figure of a man morphs into an "x." During the transformation, the form evolves into an amorphous shape before becoming identifiable as a letter. The shape appears to become meaningful before its precise meaning can be discerned. During this process, the viewer must cease to perceive the image as an image, and begin to read it as a letter. Both the "x" and the man are bound up in the same form, but revealed over time. The temporal connection between these two signs is also meaningful, as it prompts the viewer not to consider each message in isolation. © Barbara Brownie.*

between the symbolic (verbal) and the iconic (visual)." However, in these previous artifacts, word and image are "bound by the rigidity of the page" (ibid., p. 43). In contrast, fluid signs escape this "constancy" (ibid., p. 49). In holopoetry, "the boundary between word and image is assigned to time" (ibid., 1995, p. 35). The verbal and visual identities do not co-exist, but instead are exchanged for one another. Temporality, therefore, is key in this relationship between word and image.

As with written or spoken language, the meaning of a fluid artifact "unfolds during a passage of time" (Kac, 1977 [1996], p. 25). The meaning of the form is not wholly identifiable at any one moment. Instead, meaning is gathered on a journey from text to image. Louise Krasniewicz (2000, p. 53) proposes that a transforming subject may "move laterally across categories to gather knowledge from each place of (however temporary) residence." In this way, the various meanings that are contained within the fluid form, and the behaviors by which those meanings are accessed, all contribute to a greater message. The verbal meaning of the form at its most legible moment only provides a sample of the overall meaning of the artifact.

The transformation from text to image, or vice versa, can reinforce, clarify, or contradict the meaning of the text. In the Channel Five ident, *Free* (BB/Saunders, 2006, see Plate 9), the initial scene depicts balloons floating in the sky. The balloons may be associated with children's parties, flight, or any number of related events/ideas. As the balloons align to form the word "free," unwanted connotations are eliminated, and the "preferred meaning" (Hall, 1980) of the scene is emphasized. The text also has the number of possible connotations restricted as a result of its appearance in the same sequence as floating balloons. The meaning of a word which may, in other situations, be associated with financial cost, is narrowed to meanings that are shared with the drifting balloons. The viewer is made aware that "free" refers to a natural, unrestricted freedom that has been connoted by the "free" movement of the balloons in the breeze. Terence Hawkes (1977, p. 121) observes that it is the act of "transcoding," of translating from one language to another, that generates meaning. Meaning, therefore, "arises from the *interplay* of signs" (ibid., p. 122). In this example, the "interplay" is overt. The transition from text to image is a defining characteristic. This transition, according to Hawkes' observation, is what gives the artifact meaning. By being juxtaposed in time, the connotations of the image and text are shared. A "transfer of meaning" (Rose, 2007, p. 84) occurs in conjunction with the alignment of the

balloons. When a form retains properties in this way, despite change, it creates an "objective correlate" (ibid.) between the identities seen at the two poles.

In this context, legibility may be interpreted as relating to the clarity of meaning of the whole artifact, rather than an individual letter. If the understanding of a fluid form is not only dependent on the viewer's ability to recognize it as a letter, but also their ability to perceive connections between the verbal and pictorial poles, legibility is not simply a question of letter recognition. Rather, it requires a more complex reading of the artifact as a whole.

Fluctuating legibility and asemisis

At the poles of a fluid transformation, a form can be easily identified. It is recognizable as a particular letter or object. However, when undergoing transformation, having lost its initial identity, a fluid form cannot be identified as "one thing or another thing" (Kac, 1995, p. 45). It is a "nonsemantic" arrangement or glyph, being neither text nor image, but something "in between" (ibid., p. 60). The form may be loaded with potential meaning, but no meaning can be precisely identified until a later stage in the process of transformation.

Intermediate glyphs emerge as a verbal form transforms into a pictorial form, or vice versa. These glyphs bear some resemblance to written or typographic signs, but cannot "be substituted by a verbal description" (Kac, 1997). Kac (1995, p. 45) argues for the significance of these glyphs. He suggests that, in fluid type, we must also consider the intermediate stages of transformation as significant, proposing that they are a new kind of sign that lies part-way "between a word and an abstract shape, or between a word and a scene or object." His suggestion that they are a "new" kind of sign may be challenged by the identification elsewhere of signs which also bear resemblance to writing or type, yet which have no prescribed meaning.

In the diagram below (Figure 5.2), a letter "k" is shown morphing into the letter "m." At the stages in between, the fluid form bears resemblance to either the "k" or "m," or both simultaneously. In the initial stages of metamorphosis, it begins to lose legibility, before becoming impossible to decipher at the midpoint in the transformation. At this point, it is part "k" and part "m," but identifiable as neither. The hybrid form is glyphic, and appears to contain potential meaning, but its precise alphabetic meaning cannot yet be identified. Similar glyphs also appear in many of the artifacts discussed in this book, including Komninos Zervos' *Beer* and Dan Waber's *Argument* (see Chapter 9).

k k k k k m m m

Figure 5.2 *A "k" morphs into an "m." As it transforms, the "k" ceases to be recognizable, and becomes an abstract glyph, before it is eventually resolved into an "m." At the midpoint, it is identifiable as a linguistic form of some kind, but its precise alphabetic value cannot be determined. It is at this point that it is "asemic."* © Barbara Brownie.

In this direct transformation from one identity into another, features of lettering remain despite the loss of precise verbal meaning. These morphing signs therefore continue to retain character-istics of verbal signs, despite changes in their precise identity. In this case, series and variable stroke widths—the indicators of a roman typeface—help to preserve the impression that this is a verbal sign, and that it should be possible to read it. Kac (1995, p. 45) proposes that these glyphs are "a new kind of verbal unit" arising as a consequence of fluidity. However, signs which function in similar ways can be observed elsewhere, in static media, and have been described by Tim Gaze (2008b, p. 2) as "asemic." "Asemic writing" is defined by Gaze as a form or collection of forms "which appears to be writing," while "having no worded meaning." Asemic forms may bear the hallmarks of writing, either through their shape or organization, but have no specific verbal signification.

Asemic signs appear in numerous static artifacts. Historically, they have been found on forged money, as well as pottery from Ancient Greece, and personal ornaments from Iron Age Scandnavia, which were inscribed with "fake runic letters" (Whittaker, 2005, pp. 32–3). More recently, asemic signs have appeared in poetry and art, including Xu Bing's *A Book From Sky* (1988). Bing's art installation features 400 handmade books and suspended scrolls, each of which is filled with text that at first glance appears like Chinese writing, but on further inspection "is utterly without meaning" (WGBH, 1999). Bing invented 4,000 asemic characters for his scrolls, and arranged them in linear rows as if to aid the process of reading (Leung and Kaplan, 1999, pp. 88–9). The design, arrangement, and context of the characters invited viewers to approach the artifact as readers, but left them unsatisfied by denying access to a particular verbal reading.

In his explorations of asemisis, Gaze (2008a, p. 13) identifies a continuum that exists "between abstract image and legible writing," or "between text and image." Gaze argues that, at one end of the continuum lies "legible writing," which sits beyond "asemic writing," then "abstract images," and finally "recognisable images" (ibid.). These four distinct categories can be observed as points in fluid typography. Forms are often introduced as "legible writing," then transform, losing their linguistic identity until they become "asemic," then eventually abstract, and finally adopt an additional identity, that of a "recognisable image." This behavior occurs in reverse in BB/Saunders' *Love* ident (see Chapter 3), in which an image of an egg morphs into abstract shapes, then into asemic glyphs, then finally into legible letters. Not all fluid typography follows the entire continuum, as poles of transformation may be from the same paradigm. One letterform may transform into another. However, in order to achieve the adoption of a new identity, they must necessarily travel at least part way along Gaze's spectrum before returning, becoming, at the very least, asemic.

Asemisis itself performs a function in these "phases of legibility," by preparing the viewer to seek out language. When a fluid form begins to take on the properties of writing, such as the markers of a particular typeface, the viewer becomes prepared for the alphabetic meaning which is about to emerge. The visual suggestion that these forms, though without specific meaning, are some sort of language, helps to encourage the viewer to approach the artifact with the expectation of reading. For example, protrusions at the top and bottom of forms may remind the viewer of ascenders and descenders, thus making it possible to predict the emergence of roman lettering. Once they have prepared themselves to take the role of reader rather than viewer, audiences may more quickly identify the letter when it begins to emerge, in effect, increasing legibility.

In Emrah Gonulkirmaz's *Brink* (2012, see Plate 10) dark bubbles sink through a yellow liquid, before settling into a uniform arrangement and morphing into the letters of the word, "brink." As bubbles, these forms are perceived pictorially. However, once they have settled into horizontal alignment, it becomes evident that they may be more meaningful. Their regular spacing and similar size resembles the layout of writing, providing an indication that letters are about to emerge. In this way, the reader is made prepared to read the forms from left to right, even before their precise alphabetic meaning is revealed.

Asemisis and the search for new knowledge

Though asemic signs may themselves defy definition, the state of asemisis is itself meaningful. The apparent presence of a language, which challenges viewers to act as readers, combined with the absence of any readable text, has cultural connotations.

By being neither figurative nor abstract, asemic writing is difficult to categorize, and asserts its otherness. As Vilem Flusser (1991, p. 2) observes, "writing becomes almost mysterious if we discover it by deliberate consideration." Fluidity forces such consideration of writing, by bringing letterforms into being in view of the audience. The mystery, that Flusser attributes to "consideration," may combine with the unfamiliarity of asemisis, to create the impression of otherness. This makes it ideal for expression of exoticism or otherworldliness. Fluid transformation between the roman alphabet and other, unidentifiable glyphs, connotes contact or conflict with alien cultures, and is a method used in the title sequences for *Alien* (Ridley Scott, 1979) and its sequels, including *Prometheus* (Ridley Scott, 2012). These sequences initially depict single geometric lines polygons, arranged linearly to connote writing. New forms are introduced sequentially, laid alongside one another so that they eventually construct alphabetic forms that spell out the title of each film. In *AVP: Alien vs. Predator* (Paul W. S. Anderson, 2004) a similar technique is applied to the whole credit sequence. Strange symbols, resembling an unknown alien sign system, appear in familiar linear arrangements that suggest the presence of written language. These forms fluctuate, as if trying to resolve themselves in search of meaning. Eventually that meaning is found as the forms adopt familiar alphabetic shapes, spelling out the names of cast and crew.

The otherness of asemic signs may create a level of discomfort for the reader. In challenging the reader to read something that he or she cannot, asemisis reduces the reader to a state of feeling uninformed or uneducated. The asemic signs in Xu Bing's *Book From Sky* (see above) relate to issues of cultural misunderstanding and miscommunication, specifically the sense of discomfort that may be experienced when one is faced with signs that cannot be deciphered. They demonstrate that asemic signs motivate the desire to understand, and then the frustration of never having that desire fulfilled.

This sense of discomfort provokes audiences to seek a solution by searching for meaning. In fluid typography, it increases anticipation for the emergence of more familiar signs. There is, therefore, in the intermediate stages of transformation, anticipation for the arrival of the next pole, caused by the desire to escape a period of apparent miscommunication.

Until the alphabetic identity of a fluid form emerges, the viewer experiences an unsettling inability to decipher meaning which is akin to the experience of illiteracy. Indeed, asemic writing

is sometimes associated with the process of learning to write. By creating "pseudo-writing," children familiarize themselves with the practice of writing, and many of its conventions, before acquiring familiarity with specific sets of characters.[3]

Connections between asemic glyphs and processes of learning are demonstrated in the fluid typography that punctuates many episodes of the American children's television show *Sesame Street*. *Sesame Street*'s animated alphabets offer numerous examples of transforming and distorting letterforms in examples from 1969 onwards. In this educational environment, where audiences are in the process of learning not only the sound of each letter but also its appearance, the form becomes particularly important. In the context of this television show, whose target audience includes children who are learning to identify letters of the alphabet, the emergence of a letter is a valuable lesson. *Sesame Street's Psychedelic Alphabet* animation (episode 3702, 1998) features a total of 25 metamorphoses, as each letter of the alphabet transforms into the next. The *Sesame Street* alphabetic animations are intended to be educational, to familiarize viewers with the relationship between letter-sounds and letterforms, as well as the sequence in which they appear in the alphabet. Through each stage in a morph, new meaning is conveyed, and new knowledge is acquired. It may reveal to the audience new information about its nature, its purpose and its destiny, or may itself acquire new knowledge, where transformation represents the personal development of a subject. In this animation, the pleasure in encountering identifiable letters within the transforming form is reinforced and rewarded with a voice-over which names each letter. Viewers learn that the intermediate stages, though resembling letterforms in some respects, have no specific verbal meaning, and so are not useful in communication. When each asemic glyph morphs into the letter that exists at the next pole, the child is rewarded with the same sense of satisfaction that she may get when learning any new information. Through education, and through this *metamorphosis*, something that has previously been strange and frustrating becomes something that the child can identify and understand.

More recent artifacts such as Orgdot's *The ABC Game* (2002) employ fluidity, and hence asemic forms, to actively engage young audiences in the creation of letterforms. Orgdot's game, targeted at primary school children, invites users to solve alphabetic puzzles (Orgdot, 2002). Through *construction by motion of parts*, users piece together abstract shapes to create the letters of the alphabet. By identifying the place of individual lines and curves within the larger form of each letter, users become familiar with the local details of letterforms. Through construction, these users are taught to view the letter not as a whole, pre-existing, and pre-determined sign, but as something that can be created, or written, by themselves.

Historically, the value of literacy has given value to all written forms, including those that are asemic. Many past examples of asemic writing (referred to by Helène Whittaker (2005, p. 29) as "pseudo-writing") can be found in artifacts produced by and for illiterate people. As Whittaker (2003, pp. 32–3) observes, Greek Archaic vases occasionally included "fake letter-forms." In these cases, since literacy was reserved for the elite, pseudo-writing was "associated with the expression of status and power" (ibid., p. 30). The purpose of "fake writing" on, for example, Greek vases, "was to increase the prestige and value of the vase" (ibid., p. 32). This connotation of exclusivity may be attributed to fluid forms at moments of asemisis, and further, the revealing of meaning as those forms become legible can appear as an invitation to an exclusive club. The viewer may feel privileged to be shown the meaning of these previously mysterious forms.

When identifiable letters are elusive, and therefore exclusive, as they are in fluid typography, they appear valuable. This enhances the value of the moment of revelation, when the alphabetic meaning emerges. This is particularly important in idents, when the creator's aim is to prioritize a brand name or logo above all other visual elements, or to persuade viewers to appreciate the value of the letterforms that are presented on screen.

The progress from asemisis to legibility is aspirational. It is as if the asemic signs desire to be understood, and their goal is achieved as they finally adopt legible shapes. Similarly, the identification of precise meaning as it emerges presents a moment of satisfaction: the satisfaction of newly acquired knowledge. In this way, the viewing of fluid typography is akin to learning. As asemic signs become legible, new knowledge and understanding is granted to the reader, as if he or she has just learned to read.

Peter Schwenger (2012) proposes that "the rise of asemic writing comes as a pivotal point in time," when "writing is no longer an essential component" of communication; when "we are on the verge of leaving behind alphabetic writing and the modes of thought that are associated with it." We are currently experiencing what David Crow (2006) describes as "a shift toward the image from the written word," in which our media-saturated and multi-cultural societies communicate more immediately, more readily, and more universally, through pictorial forms than through words. Fluidity, which directly connects text to image via temporal behaviors, echoes this shift. It prepares audiences, who may previously have experienced an environment saturated with text, for a new environment saturated with images. Moreover, by containing both text and image within the same form, it draws parallels between these two paradigms, demonstrating that they can communicate in similar, or equivalent, ways.

6

Reactive and generative behaviors

Interactivity and reactivity

Any kind of onscreen kineticism can be pre-determined by the designer, who selects the appearance and behaviors of each on-screen form. Interactive media have introduced the possibility that this kineticism may be, in part, controlled by the viewer. Interactivity, as examined by Aspen Aarseth (1997, p. 49), involves the active participation of the reader, with he or she engaging in activities that will change the state of the content of the screen. In simple interactivity, the user's actions may prompt the start of a pre-determined sequence, or may control the progression of a kinetic change. A user-prompted change may also be more complex, occurring in parallel with other on-screen events.

Any text that is interactive necessarily has a temporal dimension, since it exists in different states before and after user interference. An interactive text may therefore be temporal without being kinetic. The text may have multiple static states, each presented for a period, as static and fixed, between interactions. This was established long before the introduction of screen-based interactive media, particularly in the works of Oulipian poets.[1] Raymond Queneau's *Cent mille milliards de poèmes* (1961) was an interactive book in which each line of a poem appeared on a separate horizontal strip of paper. Rather than turning the whole page, readers could turn a single strip, revealing a new line of text while still leaving the rest of the page unchanged. By substituting lines from different strips, the reader was able to construct numerous new poems from existing text. Even though the text was printed, and therefore fixed and static, through interactivity the poem changed. It was a different poem at different times, thereby having a temporal dimension. Queneau's work is similar in its employment of interactivity to on-screen poems such as Ken Perlin's *Kinetic Poetry* (2004).

In Perlin's work, users are presented with an arrangement of words on the screen which gently float towards one another. The direction of their motion is initially dictated by their "attraction" to other words, as quantified by the frequency of their appearance alongside each other in a database of poetry (Perlin, 2004). The user is given the ability to drag these words to new locations on the screen, thereby constructing the skeleton of a new poem. As the user relocates words, this

interference changes the direction of motion of the related words. Over time, the moving words settle into a new poetic arrangement. This artifact exhibits *dynamic layout* (see Chapter 1), using a combination of automated and user-controlled movement.

In on-screen environments, interactivity is commonplace. Indeed, Lev Manovich (2001, p. 55) has observed that "computer-based media … is by its very definition interactive." This is also increasingly true of other screen-based media, including digital television. Manovich proposes that the term, "interactivity" has been rendered meaningless due to its broad applicability. Manovich (ibid., 203 p. 40) himself proposes a range of more specific terms, such as "open" and "closed" interactivity. Megan Sapnar (2003) observes that the term "interactive" may also be misleading in discussions of "new media poetry." She proposes that the term "interactivity" is too often associated with navigation between texts (as in webpages), and needs to be differentiated from the kind of "reactivity" that is exhibited in kinetic typography that responds to the user or reader.

Sapnar's discussion can be considered in the context of the distinction between global and local kineticism, as explored in Chapter 2 of this book. Sapnar observes that "interactivity" features a large network of separate documents, while "reactivity" occurs as a more local level, "self-contained … within a single space on the screen and changing … in tandem with the viewer's own movement or action." If we consider that on-screen type may be not only inter-active, but also reactive, it is possible to allow for all of the temporal behaviors presented in this book.

Sapnar further observes (following John Maeda) that reactive typography has a different relationship with time than non-reactive forms of temporal typography. While "motion graphics … unfold over time without the input of the user," artifacts such as Kyle MacQuarrie's *Mesh Typography* (2011, Figure 6.1) are static, but are given a temporal dimension through reactivity. In MacQuarrie's artifact, letterforms are connected to one another, and to the frame of the screen, through a web of lines. *Mesh Typography* has different states at different times, and each of these states emerges only when prompted by external forces. Users are able to control the number of lines in this mesh by clicking on the letterforms. Thus, the user can create multiple states, each of which is static, but only occupies the time until the user's next click.

Since all reactivity necessarily provides a temporal dimension, it is important to differentiate typography that is both kinetic *and* reactive from typography that is merely reactive without presenting kineticism. *Mesh Typography* does not exhibit any kind of kineticism, and yet has a temporal dimension that is driven by the user. In other examples, user activities may prompt motion or change. Indeed, any of the categories of kineticism identified in this book may be prompted or controlled by the viewer. Jeffrey Shaw's *Legible City* (1989, 1990, 1991), for example, can be classified as a reactive example of *scrolling* typography. *Legible City* features virtual models of cities that have been constructed from 3D letterforms. Alphabetic objects are stacked to form buildings, and users are given a simulated experience of navigating through the streets of a city via a modified bicycle that is placed in front of a large screen. By operating the bicycle in front of the screen, users proceed virtually through the typographic environment, controlling the direction and speed of the 3D scroll. Here, the on-screen motion is comparable to other *scrolling* typography, except that the path of the scroll is defined by the viewer. Such interactivity offers the viewer responsibility for their own journey through a typographic scene.

Elsewhere, users are provided with opportunities to transform *elastic* letterforms into *fluid* letterforms. In Zach Liebermann's *Intersection* (see Chapter 4), user input can interfere with the

Figure 6.1 *"Mesh Typography" by Kyle Macquarrie. In this interactive typographic artifact, the user may click parts of a web to build and destroy connections between letterforms and the frame of the screen. Though each arrangement is static, and no kineticism is seen, this artifact presents different states at different times. User interaction therefore transforms this otherwise static artifact into a temporal one. Licensed under Creative Commons Attribution-Share Alike 3.0 and GNU GPL license.*
Work: http://openprocessing.org/visuals/?visualID= 18155 License: http://creativecommons.org/licenses/by-sa/3.0/ http://creativecommons.org/licenses/GPL/2.0/

contents of the artifact, often rendering a letterform *fluid*. Liebermann allows users to change the shape and meaning of the object on the screen. Peter Cho's *Letterscapes* (see Chapter 4) present different kinds of reactivity for each letter of the alphabet. In "E" and "I," Cho's animation provides the user with opportunities to pull the letter apart into abstract polygonal sections. This level of reactivity destroys the letterform, rendering it entirely abstract. In many of the reactive fonts shared by Open Processing, users are invited to prompt fluidity by moving the cursor away from the center of the screen (see Plate 11). Assuming that the user's gaze follows the cursor, the letterforms remain legible only when the reader is looking directly at them, as if the act of observation brings meaning to these otherwise abstract forms.

Reactivity is a two-way process, in which the reader reacts to the content of the artifact, and the artifact in turn reacts to the action of the user. In this way, the artifact and its reader collaboratively construct a narrative. That is not to say that the artifact is itself purposeful or cognizant, rather that it has been programmed by its creator to behave according to a set of predetermined rules (Aarseth, 1997, p. 50). By controlling on-screen events, users share the role of creator. Users become partly responsible for what they see on the screen, the meaning of the poem, and the kinetic behaviors that are exhibited. In this way, the creator of the reactive poem is what Roland Barthes (1977 [1968] , p. 145) describes as a "scriptor" rather than an author. The meaning of the typographic arrangement, and each letter within it, is decided by both the designer and reader in collaboration. The designer does not wholly create the text, rather he or she grants access to a number of poetic and typographic possibilities.

Generative typography: The next step in reactivity

In reactive typography, kineticism occurs as a response to user input. It is also possible for letterforms to react to other kinds of external influence, as in "generative typography." Practitioners and commentators predict that the next step in the evolution of their field will be typefaces that are intelligent or "self-aware" (Giampietro, 2013) and change in real-time so that their appearance is constantly evolving.

For their 2013 awards, the Type Directors Club created typography that was programmed to respond to "the time of day, weather patterns, traffic congestion [and] Twitter activity" (TDC, 2013). Their letterforms are designed in accordance with the user's choice of component shapes, adapted to suit local data from the user's location, using, for example, time to determine color and Twitter activity to determine weight. In addition, the forms fluctuate as the user moves a cursor over each letter. This, their promotional documentary proclaims, is the future of typography (ibid.).

Generative or "code-driven" typography (Ahn and Jin, 2013, p. 1) is emerging as part of a new field of generative design, in which all aspects of on-screen design are becoming responsive to live streams of data. Generative typefaces can have "data embedded" inside the letterforms, which govern responses to particular settings and interactions (Giampietro, 2013). These typefaces are algorithmic, so that data can be input from external sources, affecting its form so that no letter has a fixed shape or style. By responding to environmental data, these generative typefaces appear to have an awareness or "a kind of consciousness" about their environment

(Krishnamurthy, 2013). They are reactive and "adaptive," changing to account for user behavior and unpredictable external influences (McCormack and Innocent, 2004, p. 2).

McCormack and Innocent (ibid., pp. 1–2) view generative design as a kind of biomimicry, drawing from "ideas of evolution, breeding, cross-fertilisation and adaptation," and closely tied to the concept of synthesis" as observed in "natural systems" in biochemistry (such as DNA). Taking inspiration from natural processes, digital generative systems may one day be able to achieve what they do in nature: "to overcome problems in design and to generate novelty and diversity from relatively simple units."

Generative designs are not restrained by the designer: "new functionality may 'evolve' through the use and interpretation of artifacts by an audience" (ibid., 2004, p. 3). Digital typographers have become "code workers" (Bootz, 2005, cited in Portella, 2011, p. 306), who no longer develop the form of a letter directly, rather they develop the the criteria or "specifications" for many possibly interpretations of that letter. As a result, many of the issues affecting interactive design are applicable in all generative typography. The reader becomes a design "partner" (ibid., p. 307), sharing responsibility for the content of the screen. These new design possibilities prompt a shift "from the primacy of objects to envisioning interacting components, systems and processes" (McCormack and Innocent, 2004, p. 1), setting behind-the-scenes programming "at the core" of this new "electronic art" (Bootz, 2005, cited in Portella, 2011, p. 306).

Responsive kineticism is built into generative letterforms, and is as fundamental to their design as their alphabetic identities. They are *elastic*, and sometimes *fluid*, by nature. Contours are constantly in flux, because the live data that defines their appearance is also constantly changing. Mary Huang's *Typeface* and *Typeface 2* (2010) were developed to fluctuate in response to the user's facial expressions. Through facial recognition software, the dimensions of the user's face are recorded, and those statistics are input as variables into the algorithm that generates Huang's typeface. As the user smiles, frowns, or tilts his or her face, those dimensions change, leading to live fluctuations in the properties of the type that appears on screen, affecting weight, slant, and x-height.

Generative techniques are beginning to appear wherever kinetic typography has existed previously, including in motion branding. Branding, which visually signifies a brand to its audience, is now capable of responding directly to that audience by adapting to changes in consumer behavior. In branding for the Exploratorium museum in San Francisco, Paul Hoppe developed a generative identity (2011, Plate 12) using an algorithm that allows for "infinite variation of the lettermark" (ibid, 2011). In Hoppe's proposed branding, the letter "e" adapts to any possible context. Online, it may vary in response to web-user behavior, and in the museum it is intended to vary to reflect event calendar data.

On Hoppe's Exploratorium website, the "e" is shown constantly in flux. For printed materials, the letters are frozen into a static typeface which captures a single moment of their fluctuation. In this way, like many generative typefaces, there is a kinetic version, whose forms constantly update with new data, and any number of static versions, which represent the appearance of the typeface at a particular moment in its evolution.

Here, as in reactive typography, the creator is not wholly responsible for the behavior of the final artifact. Since the letterform adapts in response to external forces, its behavior is subject to unpredictable change. This makes it difficult to define a reactive artifact according to any particular behavior. While one external force may result in one kind of behavior, a different force may prompt

different behavior. A certain letterform may be *elastic* under one influence, or *fluid* under another, depending on the kind of input that these different forces make. As a consequence, it can be more useful to define an artifact according to its potential behaviors than its actual behaviors in any given instance. The range of potential behaviors is defined by the creators of an artifact, but may only be exhibited if prompted by a certain sequence of external forces or inputs.

PART THREE

Case studies

7

Fluid branding: Channel 4 and its imitators

Martin Lambie Nairn and new forms of kinetic branding

Increasingly, there is a demand for logos to be brought to life. Much of this demand comes from companies involved in temporal media, such as film production studios and television broadcasters. These companies require visual identities that are conceived as dynamic sequences rather than static logos, but that must function effectively in both temporal and static forms.

Since fluid typography affects individual letterforms, it is ideal for artifacts that present only one or few typographic forms. Logos typically contain one word, or in the case of a television broadcaster, a number. With such a small quantity of forms, it is possible to experiment at a local level, within individual letters or numbers. Fluid behaviors enable a logo to come into being in full view of the audience, emerging as if to signify a grand entrance.

Television broadcasters announce their brand using idents and bumpers. An ident is a short sequence which heavily features the logo or other identifying images, typically shown while a continuity announcer trails the following programme. A bumper is a shorter sequence that punctuates a break in a show, typically at the beginning and end of a commercial break. Though bumpers do not necessarily contain the channel's logo, they generally tend to reinforce the channel's identity using colors or themes that relate to the brand's core values. Idents and bumpers have become increasingly important as digital and internet television have increased the number of available channels.

From its launch in 1982 to the present, Channel 4 has identified its presence on screen with a continually evolving set of idents. These idents signify Channel 4's core values of innovation and diversity, through a number of converging blocks which align to construct the Channel 4 logo. Channel 4 was not the first to use fluid typography in its idents. In 1971, LWT (London Weekend Television) broadcast a new ident designed by Terry Griffiths, a "ribbon" extended downwards from the top of the screen, then twisted and folded to form the corner of an "L," a "W," and the crossbar of a "T." The motion and path of this ribbon was said to represent the flow of the river Thames. Though other idents such as this employ fluidity, Channel 4's is arguably the most significant. This innovation was acknowledged by others in the branding and graphic design industry, as

Lambie Nairn's work was seen as heralding a new era in television branding, and won numerous awards (Fanthome, 2007, p. 258). In the 12 years since its first appearance, Martin Lambie Nairn's celebrated ident has been hugely influential. The sequences were so successful that they continue to influence current Channel 4 idents, which, despite significant stylistic updates, employ the same fluid behaviors as Lambie Nairn's original series. The behaviors have also been imitated by other UK channels, including Five.

Martin Lambie Nairn's first Channel 4 idents signified the practice that set Channel 4 apart from other British television broadcasters at the time: that of sourcing a variety of television shows from a range of production companies (Woolman and Bellantoni, 1999, p. 34). This practice is illustrated in the coming-together of visibly different elements in the construction of the Channel 4 logo. In Lambie Nairn's first series of idents, colored polygons converge towards the center of the screen, against an empty black background, and align to form the figure "4." At this moment the polygons appear to undergo a change in identity, becoming parts of a number. A single identifiable sign emerges, and the polygons appear to shift from one paradigm to another: pictorial or abstract, to numerical.

In constructing a numerical character from separate pictorial forms, Lambie Nairn intended to assert Channel 4's difference from existing broadcasters. In particular, he wished to communicate the channel's aim to provide "diversity and innovation" in its programming (Docherty et al., 1988, p. 6). The innovation, which set this ident apart from those used by ITV and the BBC at the time, came in the form of the use of pictorial 3D elements in the *construction* of a numerical whole. Diversity was also viewed as particularly important in establishing the character and methods of the new channel. As opposed to the production role of other channels, Channel 4 saw itself as a "publisher," selecting and broadcasting programmes produced elsewhere (ibid., p. 8). This role as a publisher was one way in which it aimed to promote diversity, as it gave minority groups the opportunity "to express their views unmediated by television bureaucrats" (ibid., p. 36). By directly depicting the construction of the logo from separate parts, Lambie Nairn's ident effectively conveys not only Channel 4's role as publisher, but also the relationship between this role and the ambition for diversity. The convergence of several differently colored polygons acts as a metaphor for the sourcing of programmes from different production companies, and for collaboration between culturally diverse groups.

All of Lambie Nairn's idents aim to communicate these values of innovation and diversity, using *construction through motion of parts*. However, each ident involves slightly different *motion of parts*, and differently shaped components. This capacity to adapt communicates to audiences the message that the channel is not only diverse, but able to respond to change and constantly reinvent itself without compromising its core values. In the very first of Lambie Narin's idents, *Round and Back* (1982, Plate 13), the viewer is presented with the "4" logo from the very beginning breaking apart into its component polygons. The polygons are flung outwards from a revolving central column—the vertical stroke of the "4"—and then spin as if caught in a vortex, before returning to their original positions, as if attracted by a gravitational force. This motion is chaotic, with little synchronicity in the motion of the separate parts. In 1983, the sequence was extended so that the second appearance of the "4" was followed by its breaking apart again, with the separate polygons flying out of the frame so that they may be imagined entering the real space occupied by the viewer. Other idents subjected the polygons to entirely different motion. In *Implosion* (1982) the same polygons are used, but their motion is different. They originate from off-screen, and enter from every

direction, revolving as they converge on the centre of the screen, where they align to present the "4" configuration. In a few other examples, not only the motion of parts, but also the appearance of those parts, is changed. The familiar polygons are replaced with differently shaped objects, as in *Interlock* (1982), in which the "4" is constructed from an array of planar objects. Alternative versions of this ident continued to be developed, each with a variation of the same process of *construction*.

Round and Back differs from Lambie Nairn's later idents in two key ways. Firstly, it offers viewers a preview of what is to come: viewers see the figure "4" at the beginning and the end of the sequence. Therefore, there is no doubt about the intended purpose of the separate polygons, and their identity as part of a group. Secondly, *Round and Back* presents more chaotic motion than can be seen in other Channel 4 idents. In further idents (for example, *Implosion*) the motion of separate parts is often similar in pace and direction. The presence of the figure "4" at the very beginning of *Round and Back* perhaps explains why this first ident can sustain more chaotic motion than is exhibited in other idents. Since the "4" appears at the beginning of the sequence, and the viewer directly witnesses it breaking apart, past knowledge of the configuration, as presented in the first moments of the sequence, can be relied upon to affirm the identities of the separate polygons as part of a group. It is therefore not necessary for the characteristics of the motion to suggest that the moving parts are associated with one another. In short, the chaos of the motion is compensated for by the presence of two identical poles of transformation, where there is more commonly only one.

Modularity and text/image relationships in the Channel 4 logo

The *construction* of the Channel 4 logo from independently moving parts is dependent on the fact that the logo is not a single form but several separate shapes in a particular arrangement. Modular lettering requires the reader to perceive separate forms as part of a greater whole. The viewer may initially perceive the separate parts as objects or images, but must discard those abstract or pictorial interpretations of each part in favor of an interpretation that considers the entire arrangement. In Gestalt terms, the whole is more than the sum of its parts.

The Gestalt "mosaic or 'bundle' hypothesis"—that "every 'complex' consists of elementary contents or pieces" (Wertheimer, 1923, p. 12)—is broadly applicable in all lettering and typography, in that letterforms can be considered a collection of parts (strokes in handwriting, or more regular parts in type), but are perceived as more complex wholes, and likewise that words are collections of letters. This distinction between the perception of the global and the local is recognized in typographic practice, where the practices of typeface design and typography (the application of typefaces) are considered distinct (see Chapter 2). In examples such as the Channel 4 logo, or indeed any other modular lettering, the typographic whole is formed from separate parts. These parts attain particular significance when perceived as contributing to a whole.

Construction, as opposed to other methods of creation, leaves the component parts as whole forms or objects in their own right: part of a number but still independent. This allows each individual part to have its own independent identity, that may be retained despite fluidity. This in turn enables the modular Channel 4 logo to have several simultaneous identities: there is the group identity of the number "4," and the separate identities of each component part.

Elmar Holemstein (1983, pp. 45–55) identifies, in modular lettering, a "double articulation," in which a letterform may be broken down into non-verbal component parts. These component parts, or primitives, may be abstract or graphical, as they are in Lambie Nairn's Channel 4 idents, or they may each have a pictorial identity, as in MPC's more recent Channel 4 idents (which will be explored below). There are, therefore, two possible interpretations of each arrangement, as type or image: at a local level, there are multiple graphical or pictorial identities, and at a global level there is a single verbal identity. As in much typography, there is a "plurality," whereby forms communicate two distinct messages: one "graphemic" and one "phonetic" (Tsur, 2000, p. 752). This plurality causes the Channel 4 logo to be both pictorial and numerical at the same time.

In Lambie Nairn's original idents, the visual properties of the separate parts are similar enough that they are seen to be somehow associated even before they have aligned into the "4" configuration. In more recent *Atlas* idents (2004–10), however, there is a clearer distinction between text and image, manifested in the fact that the separate parts initially appear to belong to a pictorial scene.

For the new series of *Atlas* idents, The Moving Picture Company (MPC) was employed to retrieve some of the core characteristics of Lambie Nairn's processes, while introducing new features to demonstrate the radical change that had come about as a consequence of "the arrival of many new digital channels" (Fanthome, 2007, p. 264). The introduction of digital television meant that Channel 4 could no longer position itself as the most avant-garde television broadcaster. In this new broadcasting environment, Channel 4 was one of the few UK broadcasters with a history. By revisiting its original idents, the channel was able to remind viewers of its familiarity and longevity, while a digital facelift reassured audiences of its continuing remit for innovation.

The *Atlas* idents present similar construction behavior to Lambie Nairn's idents, but incorporate significant visual difference with the addition of figurative objects, digitally modeled to imitate live-action footage (see, for example, Plate 14). In these idents, the component parts of the "4" are "subtly disguised as elements in each environment shown" (MPC, not dated). MPC's idents exhibit what Roland Barthes (1977 [1961] , p. 26) conceived as an "amalgamation" of "graphic and iconic" signs.

That the component parts of each "4" configuration resemble photographed or filmed objects transports Channel 4 idents from the field of motion graphics to that of live-action film and video effects (VFX). The visually complex objects in MPC's idents therefore belong, at least in this way, to a different paradigm from the abstract primary-colored polygons of Lambie Nairn's earlier idents, which bear more similarity to graphic design than to photography or film. The addition of visual complexity to the component parts of the scene is balanced with a simplification of the fluid process. MPC's processes are more consistent than those seen in Lambie Nairn's range of idents. MPC always presents only nine component parts, and always constructs the "4" at only one moment in the sequence. They have, however, introduced a significant alternative behavior to this set of idents, by constructing the figure "4" not only through the motion of parts, but alternatively through parallax. MPC's idents can be divided into two categories: those which present *construction through motion of parts*, in which "moving material" aligns into the "4" configuration; and those which exhibit *construction by parallax*, in which a "first person perspective camera moves through the sequence to reveal the Chanel 4 logo at the midpoint" (MPC, not dated).

By using parallax, MPC have enhanced the perception that the separate parts of the "4" are embedded within the landscape, and hence that they are images rather than typography. It is only at the moment of alignment, as the tracked camera enters the "viewing zone," when audiences are able to recognize the additional numerical significance of the on-screen forms. At this moment, they appear to become numerical, without fully abandoning their pictorial identity. It becomes apparent that one or both of these identities is a masquerade or performance. Both the image and numerical identities are present, but not complete or innate. The "4" form is a collection of images or objects, masquerading as a number.

In this collection of idents there is a trend towards an ever more abbreviated alignment. The time for which the "4" configuration is in alignment has decreased to the extent that recent idents, such as *Blackpool* (2011) and *Abbey* (2011), reveal it so fleetingly that viewers must be dedicated to seeking it out in order to notice its split-second appearance. In some cases (as in *Abbey*, Figure 7.1) the "4" never fully completes its alignment, providing viewers with only enough alignment to demonstrate the potential for "4" rather than a fully complete figure. This trend illustrates the extent of the success of this set of idents, and the familiarity of their behavior to the target audience. The audience has become so familiar with the behaviors exhibited in this set of idents that they no longer cause surprise, but instead present a challenge to the viewer, to anticipate the point of alignment by seeking out the component parts of the "4" before they align. The idents are, therefore, no longer simply spectacles, but rather games, involving participation from the audience. The apparent need for the alignment to be abbreviated can be considered in light of the findings of Sarah Kettley, who has observed that, when audiences are repeatedly faced with ambiguous but similar artifacts, "the rates of visual output … had to be substantially speeded up in order to hold the attention of viewers" (Kettley, 2005). Kettley's research would suggest that the increasing speed of the behavior is required to fend off fatigue in an audience who has been exposed to similar behaviors for almost three decades.

Masquerade and illusion

In *Tokyo* (2006, Plate 14), and other recent idents including *Road Signs*, *Alien*, and *Bowling* (2004), and *Abbey* (2011, Figure 7.1), the introductory moments depict everyday scenes and activities. Objects within the environment appear familiar, and are expected to reliably behave as they do in real-life settings.[1] When these objects align, they appear to defy the rules of reality. The scene is abruptly cast out of reality, and suddenly becomes spectacle. As in the earliest forms of mechanically created spectacle, "we know what we are seeing to be impossible and yet the pleasure of the experience is in seeing—before our very eyes—the most realistic staging of something which cannot happen" (Slater, 1995, p. 219). This moment is designed to surprise the viewer, and challenge his or her assumptions about the nature of the on-screen forms. In many ways, this is comparable to a theatrical illusion.

These idents can be likened to two forms of spectacle: theatrical illusion, and computer-generated special effects. They may be described in terms identified by Reginald Foakes, as "scenic illusion," involving the creation of a spectacle within an artificial landscape. Unlike other forms of theatrical illusion, this takes place without the apparent presence of "human action,"

Figure 7.1 *MPC, Abbey, Channel 4 ident, 2011. In this ident the figure "4" never fully aligns. The viewer is provided with a lengthy introductory sequence, in which she may seek out possibilities for the appearance of the "4," and then finally is rewarded with enough alignment to prove the existence of the complete figure, without ever revealing it in its complete state. © Channel 4.*

with all illusion contained within the elements of an apparently inanimate scene (Foakes, 1989, p. 271). MPC's idents also have key features in common with "dramatic illusion." The moment of revelation, when the apparently environmental objects align to present a "4," is comparable to the climax of a dramatic illusion: "a moment of surprise ... when the spectator suddenly realises his expectations were wrong" (Lamont and Wiseman, 2005, p. 50). In this moment, the environmental objects that construct the figure "4" are initially perceived as belonging to the landscape (in Gestalt terms, the *ground*), but are revealed as belonging to a different paradigm (the *figure*). However, despite the fact that they adopt a new identity, the physical appearance of these objects does not change. Each polygon may still be identified as a separate architectural object. Therefore, in these idents, as in illusions, "there are two or more quite different interpretations from a single stimulus" (Block, 2002). Objects are simultaneously environmental and typographic. Both interpretations are correct, but also distinctly different.

Theatrical illusions succeed at creating spectacle because they result in the unexpected. In order to ensure that the climax is unexpected, the illusionist must first lull the viewer into a false sense of security by disguising his tools as everyday objects (Tognazzi, 1993, p. 356). In this disguise, "naturalness" and "consistency [are] key to conviction," and will convince the viewer that the objects are not capable of anything extraordinary (Fitzkee, 1945, p. 355). In film, as in theatrical illusion, events or effects leading up to a moment of spectacle must appear "plausible." This plausibility is achieved when "representations are internally consistent" and "coherent" (Slater, 1995, p. 232). In computer-generated spectacle (usually 3D animation), objects must be

rendered to such a high level of believability that they eliminate all suspicion (Tognazzi, 1993, p. 357). In MPC's Channel 4 idents, the illusionist's tools are replaced by the components of the fluid "4" configuration, which are "rendered [with] ... textures ... to ensure that they appear to be part of the environment" (Heusser et al., 2007). The objects blend seamlessly into the backdrop, as if they are no more capable of magic than the surrounding scenery. This disguise fools the viewer into believing that these objects are everyday architectural objects, with no potential for transformation. The perception that these objects are in no way special, or distinct from the surroundings, ensures that the emergence of the "4" will be "a moment of surprise" (Lamont and Wiseman, 2005, p. 50).

Influence

As a sizeable body of work, the Channel 4 idents represent a significant contribution to the field of motion graphics. Since their introduction, other television broadcasters, including Five (since rebranded as "Channel 5"), have followed suit with idents that display similar behaviors. Five's *Free* and *Fear* idents, explored in Chapter 4, similarly position the viewer so as to witness alignment of parts within a scene. In these idents, as with those of Channel 4, *construction* happens by *parallax* (in *Fear*, see Chapter 4) or through *motion of parts* (in *Free*, see Chapter 5). MTV has also followed suit, with a series of bumpers that construct the "M" of the broadcaster's logo from a variety of surreal objects.

MPC's recent explorations into anamorphosis have not only inspired other practitioners to follow suit in temporal typography, but have also inspired Channel 4 to explore the potential presentation of their logo in other settings. The virtual compression of space, as prompted by camera navigation in MPC's idents, was replicated in reality in an installation that appeared outside of the Channel 4 headquarters from 2008. In celebration of Channel 4's 25th anniversary, a 48-foot tall steel model of the logo was constructed and installed at the company's headquarters (Ozler, 2006). The component parts of the giant logo were not positioned on a single plane, but spaced apart, so that they could only be viewed in alignment from a position directly in front of the building. This "4," as a real-life arrangement of objects rather than computer-generated models contained within a screen, highlights the fact that the behaviors seen in the "4" idents are not merely a product of temporal media, but are reproducible as a real-life parallax.

This installation reflects a shift in contemporary practice, away from the treatment of the logo as a flat symbol, towards the perception of a logo as a physical object. This shift in perception has prompted other brands to follow in their footsteps, with other typographic elements constructed from photorealistic component parts. Recent experiments in fluid typography have yielded numerous artifacts that owe much to the impact of Martin Lambie Nairn and MPC, but despite this, there is still no agreed-upon understanding of the behaviors that are exhibited in these artifacts. New terminology is required for practitioners and commentators to accurately describe this flourishing contemporary practice. It is only with new terminology, like the categories presented in this book, that the innovation of Channel 4's idents may be accurately expressed and analyzed.

Ident families

With the advent of digital television, broadcasters have branched out to create families of channels, each catering for more specific audiences than the parent channel. Channel 4, for example, has spawned, among others, E4, 4Seven, More4, 4Music and Film4. Each of these sub-brands must have its own distinct identity, and therefore its own ident, while also conveying visual association with the parent brand. This requires consistency in some elements, and difference in others. While the variety of logos and idents for the Channel 4 family does achieve this consistency and diversity, the idents produced by Sky are more pertinent to this study of fluid behaviors.

Shortly after producing Channel 4's *Atlas* idents, MPC produced a family of idents for Sky 1, 2, and 3 (Plate 15). MPC's Sky idents all demonstrate fluidity, using transformation as the defining feature that unites the idents. Each channel employs a different fluid method, thereby highlighting the extent of similarity and difference of the various fluid behaviors that have been introduced in this book. In this way, the Sky idents provide evidence that practitioners, although they may not explicitly identify categories of fluid type, practice in ways which acknowledge that different kinds of transformation exist.

This book has so far identified fluid transformations according to the qualities of the transformation, however MPC distinguishes these examples from one another according to the alternative substances from which each object is apparently created ("solids," "liquids" and "particles"). In doing so, MPC's concept draws attention to the connection between an object's substance and its behavior. It shows us that we may consider there to be an innate connection between some substances and some fluid processes. *Construction*, as in the Sky 1 ident, involves solid parts, and *metamorphosis*, as in the Sky 2 ident, involves liquids. Equivalent connections between substance and behavior can be seen elsewhere in the examples that appear elsewhere in this book. Martin Lambie Nairn's and MPC's Channel 4 idents, for example, all construct the figure "4" from solid objects, while many examples of *metamorphosis* (such as Emrah Gonulkirmaz's *Brink*, see Chapter 5), present letterforms as liquid. These examples follow MPC's implication that there is a link between substance and process. However, there are examples to the contrary, which show us that this is not a universal rule. For example, *metamorphosis* is also observed in Dan Waber's *Strings* collection (see Chapter 9).

In these idents, "1" is constructed from sharp fragments, "2" forms from a flow of thick liquid, and "3" emerges from a plume of sparkling pink dust (see Plate 15). MPC's aim was to represent three different kinds of substance—"solids," "liquids" and "particles"—with behaviors that reflect the behavior of "rigid bodies, fluid dynamics and particle dynamics" (MPC, 2008). For Sky 1, a box opens to release an array of solid blue fragments, which flow in an arc through the sky, then stack to form the figure "1." For Sky 2, the same box releases a green goo which morphs into the shape of a "2." These idents display, in turn, *construction* and *metamorphosis*.

The third ident, for Sky 3, presents a pink plume of sparkling particles, from which a figure "3" magically emerges. MPC's use of the term "particles" in describing this ident clearly conveys the sense of the pink particles as separate objects, and the behavior as one of *construction*. However, the collection of particles behaves, in many respects, like a single fluid form, with malleable contours, as in metamorphosis. In this way, the Sky 3 ident introduces potential ambiguity between categories of *metamorphosis* and *construction through motion of parts*. When

component parts in a *construction* are so small that they cannot be identified as separate forms to the naked eye, their behavior may resemble *metamorphosis*.

These behaviors are not confined to a single set of idents. The same behaviors are seen as integral to the identities of the three Sky channels, to the extent that they appear in a variety of idents. In each ident, the number exhibits the same behavior, prompted by a variety of dramatic external events. Each number is exposed to the same external forces, highlighting the differences in the properties of each numerical object. In one set of sequences, "1" and "2" are exposed to flying debris from a car crash. While the impact of a car causes the "1" to shatter into pieces, it causes the "2" to splatter. In these alternative idents, each character is always made from the same substance: the "1" is always solid, the "2" always liquid, and "3" always particles. As a result, the processes by which they change are always consistent. This consistency does not become mundane, as in each alternative scenario the fluid behavior is prompted by different events. These events range from the tornado shown in the *Twister* sequences (2008) to a more playful destruction by hammer at the hands of teenagers playing a "Whack-a-mole" carnival game in *Whack* (2008). Some of these events, like the tornado and the whack-a-mole game, are destructive, leading to the destruction of the character identity, while others are creative, causing the identity of the channel to come into being. These creative processes offer the channel's identity as a gift to the viewer. Each is first contained within a box, then escapes to fulfill its destiny as a whole ident.

The idea of the channel's identity as a gift is continued in MPC's Christmas 2008 idents. Like many other broadcasters, Sky uses idents to mark a new season, and in particular at Christmas, to attract new audiences during this break from regularly scheduled programming. In these seasonal idents each character transforms into a Christmas tree. The figure "1" cracks and then breaks into fragments. These fragments float through space and become rearranged in the form of a tree, then continue to float as if each bough of the tree is revolving around the trunk like the merry-go-round in the background. In the Sky 2 ident, the "2" liquefies as if melting from top to bottom. The green goo flows down the melting object and reforms into a tree. In the final ident, the "3" bursts apart as if exploded by fireworks. The particles crackle and sparkle, and a display of tiny colorful explosions forms the shape of the Christmas tree. Each number is thereby transformed into a spectacular Christmas display, suggesting that, at this special time of year, the ordinary becomes extraordinary, and regular programming is replaced by Christmas specials.

One thing that connects *Christmas*, *Boxes*, and Sky's program-themed idents including *Lost* (2008), *Fringe* (2009) and *24* (2010), is a human presence. In all of these idents, the transformation of the channel identity is synchronized with the human observation. In *Christmas* and *Boxes*, the transformation occurs when people pass by. The transformation appears spontaneous, but is prompted by the presence of these passers-by; as if the ident is aware that it is being watched, and is consciously putting on a display for this audience, just as Sky is. A series of themed idents to promote some of Sky's programs follow the same rule. In *Lost*, each number stands on a platform in the center of an underground laboratory until a personality from the programme enters the room. In response to his entrance, each number breaks apart in its usual way (into solid fragments, liquid, or particles), and engulfs him. In *Fringe*, the solid pieces which construct the figure "1" appear in a microscopic array. On increasingly closer inspection by a personality from the show, the component parts of this array are revealed to be spontaneously multiplying, and rearranging to form the "1" configuration. In *24* the transformation occurs between two numeric

poles when a character from the show leaves her car and walks alongside the numerical object. Initially, the figure "24" is presented as if constructed from 3D versions of the modular lettering seen on digital clocks, appearing to be made from the same solid blue substance as the usual Sky 1 ident. The "2" and "4" collapse into pieces, which contract into a single form: that of the figure "1."

In each of these cases, the transformation of the ident occurs when it is being observed. It is for this reason that this fluidity may be described as Kac (1997) described the processes in his holopoems, as "behavior." Each letter object appears aware of its surroundings, enough so that it may choose to transform at an appropriate moment. It appears as though the transformation is a conscious attempt to attract the attention of the observer. Notably, in most of these examples, the performance is in vain. In *Christmas*, *Boxes*, and *24*, the transformation of the number object goes unnoticed. The observers continue to pass by, barely acknowledging the number or the display in which it is engaged, except with a brief and disinterested glance. Given the scale of the spectacle—a transformation involving objects at least as tall as each of the passers-by—it seems impossible that these events would not attract the attention of an observer. This enhances the perception that these are magical events, which occur outside of reality. While the observers are absorbed in their everyday lives, events occur that would never normally happen in an everyday scene, and yet they appear so mundane to the observers that they barely warrant a sideways glance. This communicates the message that on Sky, magical things happen all the time; in the world of Sky broadcasting, spectacle is commonplace.

8

Telling titles: The credit sequences of Kyle Cooper and his peers

Bridging the gap between typography and film

The purpose of title sequences is to establish themes, locations, and characters of the fiction that is to follow (De Anna, 2009, p. 12). One vital distinction between credit sequences and the rest of film and television is that they are a denser, and more intense, collection of signs. Due to their short length, credit sequences only contain elements that have been "meticulously" considered, and so are more loaded with meaning than any similarly short scene in the show or film that they precede. "Every single clip," John Laudisio (2010) argues, "has been encoded with different signs, consisting of signifiers and signified objects." Laudisio identifies some of the many messages that must be communicated through a title sequence. The sequence must establish context, genre, and introduce key themes and characters. Often, this is a condensing of the entirety of the film or programme. In so little time, these messages cannot be represented literally, and so must be signified through an established code of metaphors and symbols.

As Amanda Ann Klein (2006, p. 93) observes in her analysis of the credit sequence for *Deadwood*, title sequences serve a dual purpose. They must establish "the films' overall themes … provide a prologue for the narrative, or establish a mood," while simultaneously serving the "utilitarian" function of introducing "the show's cast [and] creators." While some commentators have inferred that typographic elements in credit sequences are less expressive than their pictorial background,[1] title designers such as Kyle Cooper have proven otherwise. Recent artifacts show that the written or typographic elements are often as vital in establishing mode, genre, and themes as pictorial content.

Title sequences are increasingly subject to the same treatment as the rest of the film, and the languages of filmmaking are now applied to graphical overlay, including typography on the screen. Bignell (2002, p. 139) observes that certain conventions in television production, such as the lighting or quality of camera motion, connote certain meanings. A shaky camera, for example, connotes the unmediated reality of documentary. Ellen Seiter (1987) observes that much of film and television code consists of nonrepresentational conventions. While television often connotes reality, and appears "naturally meaningful," many of these conventions are "actually

historical, changeable, and culturally specific." Seiter provides the example of a "fade to black," a transition that has come to signify the end of a film or show, but, in other contexts may signify an "experimental … style" or "amateur direction." Many of these non-representational cinematic conventions and "photographic techniques" identified by Seiter may also be present in film credit sequences, and may be applied to temporal typography. Particular use of "perspective, color, lighting, lens focal length, and subject-to camera-distance" may have similar connotations when applied to temporal typography as when applied to live-action footage. Bignell (2002, p. 192) observes that the widescreen format is used in the credit sequence of *Star Wars* to connote "immense scale of spectacle." The widescreen of film, in contrast to the narrower aspect ratio of a television, gives viewers the impression that the content is somehow substantial. When applied to a credit sequence, this same sense of epic scale is expressed to audiences.

Cinematic conventions are particularly useful when fluid artifacts depict apparently photo-realistic scenes. Typography that appears to be embedded within a scene helps to bridge the gap between fact and fiction. The content of the credits' typography refers to real actors (not the characters that are depicted in the imagery) and production crew. Therefore, in its combination of imagery (signifying the fiction of the narrative) and typography (denoting the reality of the production) it establishes a connection between the real world of which the audience is a part, and the fiction of the show that they are about to watch. In this respect, it acts as a bridge between reality and fiction, preparing the viewer to suspend disbelief for the duration of the film. This bridge is made easier to cross when the reality of the cast and production are embedded within the fiction of the film; when on-screen typography is embedded into the movie-space, suggesting that the sequence is a direct depiction of reality.

Photorealism in on-screen letterforms may also enhance the pleasure of fluidity. In establishing the expectation of reality, the moment of the emergence of a verbal form from the scene becomes even more surprising than it may otherwise have been. When letterforms are initially disguised as directly filmed objects (as they are in MPC's Channel 4 idents discussed in the previous chapter), audiences are less prepared to accept them as graphical, linguistic signs, and so the revelation that they may indeed contain linguistic information is a greater spectacle.

In Picture Mill's title sequence for *Hollow Man* (Paul Verhoeven, 2000) the viewer is presented with an array of apparently microscopic forms, suspended in liquid. As these forms float through the liquid, they come into focus and are revealed as letterforms. The letters are 3D and translucent, with curved contours that resemble those of microbes studied under a microscope. They come into alignment, taking the regular formation of letters in a word, and spell out the name of each cast and crew member in turn. Throughout their alignment, some of the letterforms remain blurry, as if a camera (or microscope) struggles to bring them into focus. Their apparently organic appearance, combined with the camera's apparent difficulty in capturing the letters in word formation, creates the impression that they are directly filmed objects.

Typographic elements may be embedded into a backdrop equally as effectively if the backdrop is styled to match the type, rather than vice versa. Many title sequences feature animation rather than directly filmed subjects, and so the backdrop may contain vector-based or hand-drawn scenes which stylistically resemble the typography or lettering of the credits. This visual similarity aids transformation between the visual and alphabetic components of the sequence.

Nexus Productions' titles for *Catch Me If You Can* (Steven Spielberg, 2002) presents typography that grows directly from elements within an animated sequence. The animation features a

combination of stamped figures and vector-based scenery, with different colors signifying a range of different locations. All elements on the screen are block-color forms, with crisp contours and flat color. In this way, the backdrop is stylistically similar to the typography that emerges from it. Elements of the background extend upwards to form the vertical strokes of letterforms, while those letters without vertical strokes appear independently to complete the names of cast and the title of the film. The extended vertical strokes literally connect the typography to the scene, and transform image into type. The relationship between type and image is reinforced by the fact that it is colored to match whichever background object is used in its formation.

Overlaying and integration

Title sequences are too frequently generalized as a presentation of "graphic over image" (Seiter, 1987, pp. 34–5). Credits frequently appear as an overlay, against a pictorial backdrop, and the relationship between these two layers is often not explored. Where this perception is enforced by designers, the relationship between production and content is not so effectively bridged as it can be where designers have considered connections between type and image. As shown in Chapter 1, in the titles for *Panic Room* (David Fincher, 2002), the use of photorealist textures may help to embed foreground text into a directly filmed backdrop, as if each letter is an object within the landscape. Visual connections between the typographic foreground and pictorial background may also be established through interaction of the various on-screen elements. As shown above, the sequences for *Hollow Man* and *Catch Me if You Can* attempt to erase the boundary between foreground text and background image by directly locating the written credits within a pictorial scene.

Title designer, Kyle Cooper, challenges the traditional layered relationship between credits and pictorial backdrop, partly through the use of fluid typography. At present, a limited number of practitioners have something of a monopoly on fluid typography. As seen in the previous chapter, MPC are responsible for a large number of the idents presented in this text, including Sky and Channel 4 idents. Likewise, the field of title sequence design is dominated, both commercially and creatively, by Kyle Cooper and his two motion graphics production companies, Prologue and Imaginary Forces. Cooper and his companies are responsible for numerous examples of fluid typography in film credit sequences. Where other practitioners have developed fluid typographic artifacts, it has often been a matter of "following suit" rather than conceiving of new ideas. Some practitioners are unashamed to admit that their transformations are "based on" other examples, including a high number of animators who have replicated the behavior seen in Cooper's *Transformers* credit sequence.[2]

Kyle Cooper (2009) cites as his earliest inspiration the titles for *Dead Zone* (David Cronenberg, 1983). In Wayne Fitzgerald's sequence for this Stephen King adaptation, photographic scenes are contained within the letters of the title. Initially, the images fill the whole screen, but as the sequence progresses, geometric shapes are subtracted from the image. These shapes form the negative space around letterforms, so that eventually the contours of the words "Dead Zone" become recognizable. This sequence prompted Cooper to identify a connection between his professional typography practice and his personal interest in film, and more pertinently that on-screen typography can be filmic.

Cooper (2009) argues that type should be "integrated," not overlaid as an afterthought. Although examples like *Twister* (Jan de Bont, 1996), contain separate, but interacting, background and foreground, Cooper recognizes that the relationship between type and image does not necessarily begin with layered elements. In his sequences, type and image are not merely juxtaposed, but are a continuation of one another. His significant body of work explores various kinetic relationships between type and image, and his sequences exhibit many kinds of temporal typography, including several categories of fluidity. In doing so, he establishes connections between the typographic and pictorial elements of a credit sequence.

Integration may occur regardless of any stylistic similarities or differences in the forms and scenery. Different kinds of kinetic behavior may establish the impression that a letterform is embedded into a scene, by implying that the background environment is able to influence the typography in some way. In Kyle Cooper's titles for *Twister*, the name of the production studio, Amblin Entertainment, initially appears as a graphical overlay, against a backdrop of a stormy sky. The bold, digital type is stylistically very different from the directly-filmed backdrop, and there is initially no visual indication that they may be connected. Yet, after a moment as a static arrangement, this type becomes swept up in the storm, and the letters are blown away as if the two layers—digital and real—are interacting with one another. In the storm, the letters fold and flutter, joining a cloud of debris, and it becomes impossible to differentiate those forms that have previously been linguistic. Several fragments of debris then emerge from the storm and are blown towards the screen. As they are tossed in the breeze, the fragments revolve and briefly align, and are revealed as 3D letterforms, spelling the titular, "Twister."

Under Kyle Cooper's mentorship at Imaginary Forces, Karin Fong designed the titles for *Terminator Salvation* (McG, 2009). In this sequence the letters of the title of the film are presented as vast structures, through which a tracked camera navigates. The viewer is taken on a journey around and through these dark, monumental letterforms, traveling so close that they are not initially recognizable as alphabetic. Rather, they appear as immense, worn, metallic objects, with surfaces and protrusions facing every angle. Only towards the end of the sequence, when the camera pulls back, and the vast objects revolve so that they present their front faces, do they become recognizable as letters. The letters of the word "Terminator" initially appear so much like an image that they form the backdrop to a layer of more conventional typography. The cast and crew are overlaid in the foreground, appearing in *sequential presentation*, as the film's title slowly and gradually reveals itself in the background. This feature was borrowed from Ernest D. Farino's original *Terminator* (James Cameron, 1984) title sequence, which was similar in several respects. It also contained large, imposing lettering in the backdrop, in two overlaid layers that scrolled horizontally in opposite directions. Though the core features of the two title sequences are similar, Fong's work is able to achieve the impression of transformation of image to type in ways that the original sequence does not. Her use of navigation, which gives audiences the impression that they are traveling through the objects, reinforces their immense scale and identity as objects rather than flat signs. Furthermore, her use of worn metallic textures creates the impression of something with a material presence.

By locating lettering or typography in both the background and foreground, it is possible to suggest that letterforms can function in several different ways. By commonly featuring foreground typography overlaid onto background images, title sequences have established the expectation that all text is located on the foreground layer. The use of text in both foreground and

background, as in Fong and Farino's *Terminator* sequences, thus invites the assumption that the background text may be pictorial rather than linguistic. In Shine Studio's titles for *Taking Chance* (Ross Katz, 2009), a sans serif typeface in the foreground contrasts with live-action footage of writing in the background. This writing is filmed as it is written, so that the letters are formed on screen and viewers witness the fluctuating contours of each stroke as the ink is absorbed into paper. As in Fong and Farino's sequences, the background lettering is much larger than the foreground lettering. Indeed, it is so large that its contours extend beyond the frame of the screen, rendering it abstract. Letters are only partially visible, and are revealed in their entirety only when the camera pulls back. Throughout the sequence, the background writing becomes more legible, as the camera pulls further away. Its meaning is thereby clarified, as more visual information is revealed, and the letters apparently transform from large abstract glyphs to small handwritten words. Towards the end of the sequence, the several layers of handwritten lettering and overlaid typography begin to blend into one another, as if blending the two separate texts, and erasing their differences.

Kyle Cooper and text/image relationships

Cooper's numerous title sequences, and those created by his teams at Imaginary Forces and Prologue, exhibit many kinds of transformation that can also be termed "fluid." The sequence for *Transformers* (Michael Bay, 2006) exhibits *construction through motion of parts*. In the teaser trailer, the "robust" metallic letters of the title, "Transformers," break apart into pieces, then "reconfigure," first to present the release date of the film, and then an "Autobot symbol" (Ozler, 2006). Art Director Sean Koriakin conceived of alphabetic and numerical objects constructed from "panels" that would fit together like pieces of "a giant jigsaw puzzle" (ibid.). These pieces, when rotated and rearranged, play several roles, first alphabetic, then numerical, then pictorial.

As fluidity operates transformation between type and image, fluid forms do not always need to be anchored in a pictorial background to express both linguistically and pictorially. It is often the case that, since fluid forms offer such rich content, they appear on a plain or empty backdrop. This is the case with many of Kyle Cooper's credit sequences, including the titles for *True Lies* (James Cameron, 1994). Woolman and Bellantoni (1999, p. 42) identify, in their description of this sequence, an "interplay between letterform and counterform." More specifically, this example of *revelation* presents forms that express contradictory linguistic meanings through positive and negative shapes.

Cooper's *True Lies* sequence features the film's title as the two poles of a behavior of *revelation*, achieved through the rotation of the letterforms as independent 3D objects. As demonstrated in the diagram in Figure 8.1, at the start of the sequence, four apparently planar letters are presented, spelling the word, "true." These letters are then seen to revolve, revealing themselves as 3D, and simultaneously revealing the word "lies," carved as voids into the side surfaces of the existing letters. In this way, the linguistic identity of the forms is seen to change, first reading "true," and then "lies." As the rotation begins, the viewer's initial assumptions about the nature of the forms are challenged. Although the letters, when they face forward, appear planar, revolution reveals them to be 3D. Consequently and simultaneously, the viewer's assumptions about the

space which these letters occupy are also challenged. The screen space, which is at times assumed to be a single plane on which the letters lie, is revealed as environmental, by virtue of the fact that a 3D form can only be contained within three-dimensional space.

The forms in this sequence, like many of those produced by Cooper and his team, appear "caught between a flat and three-dimensional world" (Fong, 2001, p. 37). The nature of the space and objects presented in this artifact are deceptive. When facing the viewer, both words, "true" and "lies," appear planar, having none of the usual "depth cues" that one would expect in a 3D scene (Hochberg, 1981, p. 265). The letters do not, for example, cast shadows on their surroundings. Wherever there is 2D/3D ambiguity in any artifact, the viewer will take cues from surrounding objects in order to assess the nature of a scene (Rock, 1975, pp. 49–50). By a process of "relational determination," a "perceived quality is determined by the relationship of one thing to another" (ibid., p. 57). If, as in *True Lies*, an apparently flat letterform appears on a plain background with no depth cues, it may be assumed to be 2D, and exist only on a flat plane. Without depth cues, the viewer assumes the simplest possible interpretation:[3] that the scene is flat. However, as soon as the objects begin to revolve, the perception of planarity is challenged. As the contours of each letter transform, and differently shaded areas appear, it becomes apparent that the kineticism represents "spatial rotation."[4] This, in turn, means that the on-screen forms must be 3D objects, contained within virtual space. The viewer must therefore reassess the scene and all forms contained within it. The realization that the letters exist within environmental space, rather than on a flat black plane, comes as the letters are themselves revealed to be 3D, and meaning is called into question.

Andrea Codrington (2003, p. 24) notes that the *True Lies* sequence is just one of several examples of "typographic method acting" created by Kyle Cooper. She lists, as other notable examples, the title sequences for *Twister* (see above) and *Spider-Man* (Sam Raimi, 2002), in which letters are trapped in a spider's web (ibid., pp. 15, 100). The *Spider-Man* sequence does not exhibit fluidity—the identities of the letterforms are never called into question—but other sequences by Cooper and his colleagues do display a moment of surprise similar to those encountered in fluidity. Karin Fong (2001, p. 30), who works alongside Cooper at Imaginary Forces, identifies the *True Lies* sequence as an example of an "a-ha! moment in film," equating it to several other examples in which the viewer is encouraged to "make unlikely connections between two things," particularly with "clever transitions." Fong observes that this moment of surprise is not incidental or serendipitous, but is "constructed" by the designer. The designer systematically engages in an act of misdirection, bluffing about the true nature of the elements that appear on-screen, and then revealing "with elegant sleight of hand" an alternative identity (ibid., p. 37).

Fong describes the transition from "true" to "lies" as "a simple motion" (ibid.). The behavior is indeed simple, involving straightforward rotation around vertical axes. This sequence is made to appear more complicated as a result of the complexity of the affected forms. The on-screen forms are shaped to present both positive and negative letters, combined into single objects. In the design of these forms, Cooper exploits coincidence. He is said to have "started with the obser- vation that the words 'true' and 'lies' both have four letters" (ibid.). To this extent, it exploits the visual similarity of different words. Visual similarity between the words is heightened by Cooper's use of upper case letters. Advice commonly given to typographers is to avoid the use of entirely upper case type, as capital letters are so visually similar that it becomes difficult to distinguish one letter from another (Jury, 2004, p. 70; Willen and Strals, 2009, p. 38). Cooper ignores this

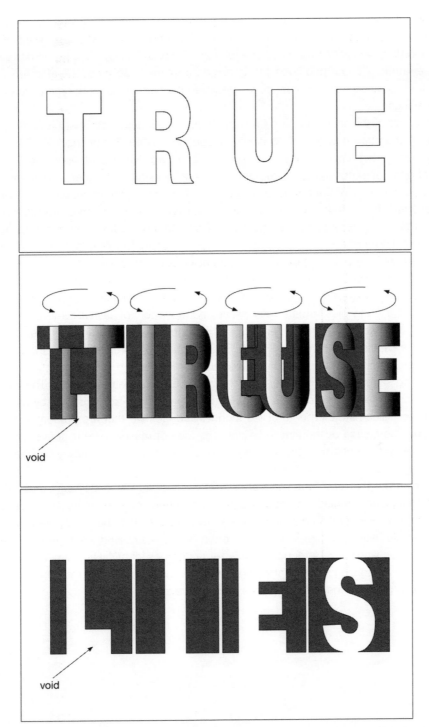

Figure 8.1 *Diagram showing the behavior exhibited in Kyle Cooper's title sequence for* True Lies *(James Cameron, 1994). In this brief title sequence, apparently flat letters spelling the word "true" revolve to reveal the word "lies" carved into voids in the side of each letter object.* © *Barbara Brownie.*

advice, and exploits the quality that many typographers perceive as problematic. In upper case, the letters of "true" and "lies" fit neatly into blocks of identical sizes. It is this similarity that allows "the two words to coexist as flip sides of each other" (Fong, 2001, p. 37). In the decision to use upper case letters, Cooper prioritizes the transition over the legibility of the affected words. He demonstrates significance in the connection between the two words, rather than in their separate verbal meanings.

In his analysis of the sequence, Jon Crasner (2008, p. 193) observes how this "effect succeeds at illustrating the title's oxymoron." As acknowledged in Chapter 3, Sobchack (2000, p. 139) has observed that metamorphosis often occurs between two "clichés of opposition." On-screen metamorphosis, she observes, "attempts to erase" binarism. Cooper's sequence demonstrates that other kinds of fluid transformation may also engage the relationship between binary opposites. Here, the different visual features of the two words reinforce their difference. The fact that "true" is figure, while "lies" appears as ground, emphasizes that they are opposite in every respect. Furthermore, that one word is hidden in order to reveal the other suggests that truth and lies are two polar opposites that cannot co-exist. However, as with *metamorphosis*, this *revelation* "attempts to erase" binarism (ibid.). It reveals that, despite their vast differences, truth and lies are inextricably linked, as emphasized by the mid-point of the transformation, in which both "truth" and "lies" are partially visible and the letters of each are interposed. The value of truth may only be appreciated when it is set in contrast with lies, and lies are only effective when told to an audience who expects truth. Fong (2001, p. 37) proposes that the transition from "true" to "lies" however, achieves something much greater and more specific than exposing an oxymoron. She suggests that it addresses "the much bigger idea of duplicity." The film tells the story of a secret agent who hides the truth about his profession from his wife by masquerading as a computer salesman. Elements of his identity and lifestyle that are presented as truth are revealed over the course of the film to be lies. The idea of masquerade is conveyed in the dual identity of the on-screen forms, and the way in which the word "true" initially conceals the word "lies."

It is noteworthy that each separate letter revolves individually in this sequence. This observation recalls a point first made in Chapter 2, that distinctions must be made between global and local change. The local rotation exhibited here allows each letter to be substituted by its partner. Even in examples such as this, in which an entire word is involved, each letter revolves as if around its own separate axis. Although each letter undergoes identical and simultaneous transformation, thereby reinforcing its place alongside others within a word, each rotation is independent, and fluidity can therefore be said to operate at a local level.

9

Kinetic poetry

Temporal poetry and the static page

Kinetic poetry has a smaller audience than other kinds of kinetic typography. While motion branding and title sequences often reach mainstream audiences, being an unavoidable part of our media-saturated environment, kinetic poetry must be sought out. Like some other artforms, it appears in specifically designated environments. It may therefore be considered a more specialist field than those that have been addressed so far in this book.

Presented in this poetry context, kinetic typography can be seen as having arisen from a particular history of poetry on the static page. This history establishes expectations about how kinetic poetry should be read and understood. The fact that many examples of kinetic poetry accompany a voice-over reading (while title sequences and idents do not), reinforces how poetry is often experienced as an oral performance. The emphasized connection between the words on the page or screen, and their sound as they are read aloud, is one method of differentiating poetry from other forms of writing (Furniss and Bath, 2007, p. 36).

"Sound evocation" has appeared on the printed page, in particular in the work of Futurists such as F. T. Marinetti and Kurt Schwitters (Bartram, 2005, p. 51). Futurist typography not only featured onomatopoeia, but also expressed qualities of sound through visual characteristics. In what Alan Bartram (2005, p. 70) describes as "the visual transcription of ... sound," aural qualities were expressed through "varying sizes, weights and styles." Marinetti's *Zang Tumb Tumb* (1914), for example, combined elements of sound poetry and concrete poetry, and expressed loud sounds with large, bold lettering, and reduced volume with gradually diminishing type sizes. In this way, this static typography and poetry may represent an aural, temporal experience.

Futurist poetry has much in common with concrete poetry. Indeed, Roberto Simanowski (2011, p. 58) considers kinetic poetry to be the "successor ... of concrete poetry" which communicates through visual and verbal means. Forms of picture poetry and concrete poetry present both pictorial and verbal meaning simultaneously. Theorists, including Sabine Gross (1997, pp. 16–20), observe that they have "parallel signification:" a "double signification of ... image and word," thus forming a "super-sign." Although these messages are presented at the same time in the same

forms, Georges Longrée (1976, p. 751) notes that "the iconic message is perceived all at once, whereas the verbal message requires a more deliberate and analytical reading." Although the two messages are transmitted simultaneously, Clara Elizabeth Orban (1997, p. 48) argues that they are not received simultaneously in typographic works such as Marinetti's *Zang Tumb Tumb* (1914). "They are at once images and texts, and when they are being 'decoded' in one code, we must freeze reception of the other." Likewise, Gross suggests that "as soon as letters and words are perceived as images—and thus decoded as iconic signs—they disappear as symbolic signifiers," at least while they are being "processed as images."

These observations mirror those of Gestaltists, who suggest that it is difficult to perceive simultaneously the global and local understanding of groups.[1] It is possible to experience a "Gestalt shift" from one interpretation to the other (and hence from one paradigm to another), but one is always dominant (Willows, 2005, p. 18). "Symbolic and iconic signification" are therefore, as Gross (1997, p. 18) proposes, "mutually exclusive." Jean-Gérard Lapacherie and Anna Lehmann (1994, p. 65) likewise observe that "it is impossible to read a text in a sustained fashion and at the same time look at the printed characters." There is a "conflict between characters considered as signs representing units of language" and the additional pictorial signs contained within the same characters (ibid.). However, in his taxonomy of word-and-image relations, A. Kibédi Varga (1989, p. 37) argues that, in some cases, when there is "complete union of verbal and visual elements, we cannot switch from one way of perceiving to another; we in fact perceive in two different ways at the same time."

Simanowski (2011, p. 62) suggests that concrete poetry cannot be read aloud, insofar as a reading would not express the poem in its entirety. The visual appearance of a concrete poem is as vital to its meaning as the text, and so any reading would fail to convey the poet's intentions. This, Simanowski argues, is even more true of kinetic poetry, where vital components have no oral equivalent. Kineticism and interactivity cannot be expressed in a reading of a kinetic poem, and so the visual presentation is the only way to experience such artifacts.

Simanowski's argument seems to contradict the evidence presented in examples of kinetic poetry that are accompanied by voice-over, where the oral reading reinforces the typographic contents. Manuel Portella (2011, pp. 318, 313) suggests that some digital kinetic poetry can be "a material simulacrum of reading acts," and identifies examples of interactive poetry in which "the writing … is perceived as correlative to the motion of reading." In many such artifacts, the voice-over is vital in establishing a particular oral interpretation of the words on the screen, as expressed through intonation, pitch, and other oral characteristics. Furthermore, the oral recitation prompts the reader to read (rather than just observe) the words on the screen and to read them at a particular pace. In some cases, this makes the oral reading primary, and the kinetic typography an illustration or prompt. Travis Carr's kinetic typography interpretation of Charles Bukowski's "The Laughing Heart" (2011), is accompanied by a pre-existing reading by Tom Waits. Since the audio recording preceded Carr's typographic interpretation, the oral reading can be viewed as a driving factor in the characteristics of the kinetic behaviors that are seen on-screen.

However, it is certainly true that many examples of kinetic poetry cannot be expressed through oral reading. This is particularly the case in *fluid* poetry, as a transforming sign has no verbal equivalent. In fluid poetry, the artifact is often silent, and viewer's experiences are primarily visual. Dan Waber's *Argument* (2005, Figure 9.1), which presents the transformation of a "string" so that it forms two opposing sides of an argument, although describing an oral event, could not be read

out loud without the loss of the fluidity that makes it distinct. This artifact is silent, with no accompanying voice-over or soundtrack. Though attempts could be made to read the "yes" and "no" of the poem aloud, they would be spoken as two separate words, rather than one single utterance with opposing meanings that transform over time. This kind of fluidity is an analog experience of transformation that cannot be adequately represented in speech.

Speech, or verbal reading, is unable to replicate the experience of fluidity because words do not operate in a continuum. By naming things, we reduce "the continuous to the discrete," and perceive binary oppositions in our surroundings (Chandler, 2007, p. 46). Much communication,

Figure 9.1 *A string forms the word "yes," then reforms into the word "no" in Dan Waber's* Argument, *2005. http://vispo.com/guests/DanWaber and http://logolalia.com © Dan Waber.*

as Chandler observes, requires this reduction despite the fact that much of our world, and many human experiences, are analogue, involving "graded relationships on a continuum." When only two poles of a transformation exist, as in many *fluid* behaviors, "it is particularly telling that [transformation] tends to occur between two poles that are clichés of opposition" (Sobchack, 2000, p. 139). This transformation "attempts to erase" binarism, to identify a continuum along which two extremes may rest, and, in some cases, to not prioritize the poles over the variations that exist between them (ibid.). Dan Waber's *Strings* (2005) is a series of several artifacts in which a single "string" reforms itself into first one word, then another. Each word is perceived as having a different meaning—a different identity—but is formed from the same "string." *Argument* (one of several animations in the *Strings* series) presents two contradictory meanings, bound within the same form (see Figure 9.1). The identities at the poles, "yes" and "no," are binary opposites, but *Argument* presents them on an analogue continuum. The positive "yes," becomes uncertain as it gradually loses its identity, and as the "no" forms, it becomes progressively more certain, and eventually clear.

Waber's poem operates on a continuous loop. It has no beginning, middle and end, other than those imposed by the reader as he or she navigates to and away from the webpage. This creates a sense that the "argument" is eternal, existing beyond the confines of any specific dialogue between two people.

Kineticism as performance

It may be that kinetic poetry is the next step in the development of a medium that has already transformed over its long history. As Furniss and Bath (2007, p. 36) observe, poetry was historically an oral medium, "composed and transmitted mainly by and for people who could not read or write." Over time, it has transformed into a form that is considered predominantly written. Today, poetry is viewed as something that can be spoken or written. Though the contemporary experience of poetry is "mostly through silent reading," the most frequently analyzed poetic devices, such as "alliteration [and] rhyme," are from oral traditions (ibid.). Poetry has, in this way, transformed from a predominantly spoken to a predominantly written medium, that now invites both silent and oral readings. Kinetic poetry, and other forms of digital poetry including "hyperpoetry" (Ensslin, 2007, p. 25), may be the next step in its evolution. These layer visual, kinetic, and interactive dimensions onto poetry's verbal form.

If kinetic poetry has potential for multiple readings, some visual, some verbal, and some interactive, the verbal reading could become less significant. However, reading is arguably more vital in kinetic poetry than in some of the previous examples presented in this book. While viewers may often observe film title sequences without reading their text content, audiences of concrete poetry are readers as well as viewers. In kinetic poetry, the wholistic interpretation is expected, in which audiences encounter a hybrid experience. This reading is visual, verbal, kinetic, and sometimes even haptic, and all of these readings are simultaneous, and all collaborate in contributing to meaning.

This new kind of reading can be akin to a performance. Indeed, commentators often anthropomorphize the words and letters in kinetic poetry, as "actors and dancers on the stage of the

computer screen" (Ryan, 1999, p. 2). Lee, Forlizzi and Hudson (2002, p. 81) note the potential for motion to add anthropomorphic characteristics to text. They describe how "kinetic typography" can "convey emotion," bringing human "expressions" and characteristics to letters in an act of theatrical portrayal. To that extent, the kinetic performance of poetry can inject and express emotion in a different way to an oral performance of the same text.

Through kineticism, a poem may perform itself. Its words may be presented over time, in *serial presentation* (see Chapter 1), not only to invite reading but also as a substitute for reading: as if the poem is reading itself. Performance can therefore be something that a kinetic poem offers independently of a reader (i.e. the poem is not performed by a third party; instead it is itself active). More complex kineticism, such as fluidity, can allow each letter to perform its own shape, or each word its own meaning. A kinetically treated word can grow and become visually dominant, just as an oral recitation of a poem can stress the importance of a word through volume. The style of kineticism can also contribute to the style of performance. In Komninos Zervos' "cyberpoem" *Beer* (2004) the languid progression of a *metamorphosis*, which sequentially transforms each word into the next, reflects the verbal slur of a drunken reader. Like other examples of fluid typography, Zervos' *Beer* presents the transformation of a series of letterforms, and as these forms evolve they progress through moments of illegibility and asemisis (see Chapter 5). Here, the asemisis, despite not having specific verbal signification, does have meaning. It connotes the lack of clarity in drunken speech, and the difficulty that a drunken speaker may have in selecting the correct language to express his/her thoughts.

Beer was distributed in collections of poetic works, and is most commonly discussed in the context of "new media poetry."[2] This establishes a smaller and more select audience than is likely to view the title sequences of Kyle Cooper (see Chapter 8) or Lambie Nairn and MPC's idents (see Chapter 7). It also suggests that audiences will have different expectations of this artifact than of those discussed so far in this chapter. With the expectation of poetry, a viewer of *Beer* may seek out the properties of what Hawkes (1977, p. 63) describes as "poetic language." The viewer may, for example, "seek narrative motivation" as a way of "rendering" the "relationships" between the words in the sequence as "intelligible" (Stadler, 2002, pp. 18–19). However, even if the viewer's instinct is to seek out narrative in this sequence, she will find none. The sequence reads, "beef," "reel," "heel," "help," "yelp," "yell," "tell," "tale," "sale," "salt," "malt," "mart," "mark," "bark," "bank," "book," "look," "hood," "hold," "cold," "cot," "got," "boa," "bet," and "beet." In this continuous loop, there is no identifiable beginning, middle and end, and no possibility of finding a grammatically coherent phrase. It most closely resembles a string of words compiled by the free-association of a drunken mind.

Jenny Weight (2006, pp. 434–5) suggests that, in digital contexts, verbal narrative should not necessarily be sought as it is in printed or spoken poetry. In discussing the interpretation of "computer-based" literature and poetry, Weight reminds us that "humans … seek narrative experience," but goes on to suggest that "digital textuality [has the] capacity for variation with oral tradition." It favors "variation" over "permanence," as so, in "computer-based" artifacts, "traditional ideas of literature seem to have been sidelined" (ibid., pp. 432–3). In their "randomness" and apparent spontaneity, such narratives offer the possibility of continuous exploration, rather than a closed "standard narrative trajectory" (ibid.). She cites Marie-Laurie Ryan (2001) in proposing that "narrative coherence is impossible to maintain" in the "complex systems" of digital media. Weight stresses, however, that narrative still exists in this poetry, but in the "apparatus"—the

digital poetic environment and its features—rather than in the verbal content of the poetry. It may be suggested, therefore, that narrative should not be sought in the string of verbal signs that are presented in *Beer*, but in the way that they morph; in the properties of the fluidity. This fluidity, like other "computer-based" narratives, "present[s] possibility rather than closure" (ibid., p. 433). Poetry exists not in the words, but in the possibility of continuous transformation.

Those texts that discuss *Beer* do not propose that there is any particular significance to this string of words. Instead, they focus on the behavior by which one word becomes another. Hazel Smith (2005, p. 245) describes how *Beer* "moves from one word to another by changing some letters and not others;" Ikonen (2003) observes how *Beer* "combines change and movement as the letters transform into other ones, approach and withdraw … lose their recognisable form, and then shape into new … words"; Carrie Noland (2006, p. 49) tells us that *Beer* "operates by distorting the shapes of letters until they form other letters." That these texts prioritize behavior over content suggests that the poetry is indeed in what Weight (2006) describes as the "apparatus," rather than in the verbal content. It would perhaps, therefore, be inappropriate to try and seek a particular significance in the array of words that Zervos presents in his "cyberpoem."

There is one review of this artifact that does find significance in Zervos' choice of words. Eduardo Navas' (2003) brief discussion of *Beer* describes the cyberpoem as a "careful exposure of the intricate linguistic communication network," exploring "themes of spontaneous expression." Zervos' words could therefore be understood as a depiction of an improvised, "spontaneous" utterance. It reminds us how it can be, at times, difficult to express coherently when we have no time to arrange our thoughts, or when we are under the influence of alcohol. The lack of narrative coherence draws attention to how we do not always select words for their appropriateness in a particular phrase. Words may be selected for their sound, or even their visual appearance. Indeed, Carrie Noland (2006, p. 49) suggests that "the shape of a letter" may have been a motivating factor in Zervos' choice of words. With this interpretation, *Beer* can be understood as a visual exploration of the shapes of letters, and of the asemic forms that are produced when one morphs into another, in which verbal meaning is almost incidental.

Fluidity in holopoetry

As identified in Chapter 3, the notion of "fluid" typography is drawn from the writings of Eduardo Kac. Although Kac's own works are holographic, they exhibit the same behaviors that can be found in the screen-based artifacts explored in this book.

Several kinds of fluid behavior are exhibited in Kac's holographic poems, including *construction, revelation,* and *metamorphosis.* In *Andromeda Souvenir* (1990, see Chapter 3), and *Maybe then, if only as* (1993), the viewer's navigation results in the apparent *construction* of letterforms from smaller objects. The letters may be perceived as being constructed or as breaking apart depending on the direction of the viewer's movement as she enters the viewing zone. In *Maybe then, if only as,* fluidity is observable in the first of four neighboring holograms, containing the phrase "WHERE ARE WE?" As the viewer navigates around the hologram, the word "WHERE" appears to break apart into "falling snow flakes," which fall until they land on, and partially conceal, the words "ARE" and "WE" (Kac, 1995, p. 61).

Two of the holopoems that Kac created in 1992, *Astray in Deimos* and *Havoc*, present behavior that Kac (1995, p. 58) himself describes as "typographic metamorphosis." In *Astray in Deimos*, a collection of wireframe letters spell the words "EERIE" and "MIST" at the two poles of a transformation. At a privileged location (Kac's "viewing zone") the viewer may be presented with either word, and then, moving towards another vantage point, will observe the letters of that word undergo a "topological transformation." Four of the letters in the word "EERIE" each metamorphose so that they become the letters of "MIST," while the additional letter vanishes. In *Havoc* "an abstract shape morphs into the word 'WHEN' which morphs again into an abstract shape" (ibid., p. 60). This metamorphosis takes the form of a twirl. The letters become stretched and distorted, as if sucked into a vortex, until they lose their verbal identity, becoming entirely abstract. This behavior reverses itself as the viewer moves to and from the privileged viewing zone.

A third kind of transformation, *revelation*, can be observed in *Multiple* (1989, see Figure 9.2). In this holopoem, 3D numbers can be observed from one viewing zone. As the viewer moves, she initially expects to be able to experience the illusion of walking around these numbers to view them in reverse. However, as the numbers pivot in response to the viewer's movement, the reverse view of these numbers is revealed to be a series of letters, spelling the word "POEM." It appears, therefore, that the numbers have transformed into a word as the viewer navigates around them (ibid., p. 48). It is revealed that the front face of the first figure reads "9," while its back face reads "P," and so on. This exploits the similarity of the letters in POEM to the reversed shape of the numbers "9," "0" and "3." "3," for example, when reversed, closely resembles an "E." The final digit, another "3," is presented at an angle so that it may easily be read as "m," when anchored by the presence of other alphabetic, rather than numeric, characters. This piece draws attention to the similarity between alphabetic and numeric characters, a connection that is exploited in numerous screen-based artifacts including the DVD trailer for *Tinker, Tailor, Soldier, Spy* (Tomas Alfredson, 2011), in which sequences of numbers are resolved into the letters that spell the names of cast and the title of the film.

It is useful to note that when Kac discusses fluidity in his holopoems, he observes transformation affecting a "word," not "letter" or "character." Like most examples of kinetic poetry, they

Figure 9.2 *Eduardo Kac, two views of* Multiple, *1989, digital hologram, 7.8 x 9.8 in. 3D letters of the word "POEM" appear to transform into the numbers "3309" as the viewer navigates around the hologram, revealing the reflectional similarity between the numbers and letters in both sequences.* © *Eduardo Kac.*

contain whole words, and those whole words are involved in each transformation. However, Kac's use of the term "word" is problematic for several reasons when defining these holopoems as fluid. First, one of the examples above (*Multiple,* 1989) contains a pole that is numerical, and so not a "word;" second, the transformation occurs at the level of the individual letter; third, as Kac (ibid., p. 31) notes when addressing legibility, many of his holopoems never simultaneously present the viewer with a complete set of letters forming a whole. This again raises the issue of local verses global change that was introduced in Chapter 2. Even when letters transform simultaneously, leading to a change in the meaning of the entire word, it is at the level of the individual alphanumeric sign that the properties of a fluid behavior may be observed. In order to assess each kind of transformation that occurs in these examples, it is necessary to inspect how it alters each individual letter.

Arguably, Kac's holopoems are interactive. It is viewer navigation that drives the fluid transformation, and were the viewer to choose not to move, the poem would not appear kinetic. By controlling the direction of his or her navigation, the viewer is able to view the transformation forwards or in reverse, giving the impression of a "time-reversal transition" (ibid., p. 44). He or she may also control the speed of transformation, by walking more quickly or slowly. It is through this navigation that the poem is performed. Performance, which is, in this case, the progression of the poem, is driven by the physical motion of the reader.

Conclusion

Kineticism elsewhere

This book has addressed kineticism—particularly fluidity—in the field of temporal typography. All of the exploration and discussion held here may also be applicable in non-typographic settings. This study does not exclude the possibility that similar transformations to those defined in this book may appear in other kinds of artifacts. In particular, those artifacts that use similar technologies to those applied in the creation of temporal typography may readily apply those same kinetic behaviors to elements that are pictorial or abstract.

It is already well established that *metamorphosis* exists in stop-motion, cell animation, and more recently digital animation, presenting a kind of fluidity referred to by Sergei Eisenstein as "plasmaticness," that allows freedom from a fixed form, and distortion to the point of acquiring new identities (Solomon, 2000, p. 16). The term "metamorphosis," and therefore perhaps the term "fluid," could be used in the description of a number of behaviors exhibited by artifacts ranging from Fleisher studios' *Koko the Clown* (1919) (who is turned into a shape-shifting ghost, capable of adopting numerous different guises), *Willow* (Ron Howard, 1988, in which many audiences were introduced to digital morphing for the first time), and *Terminator 2* (James Cameron, 1991, which demonstrated "seamless" morphing from a human-like form first into liquid metal, and then other solid objects) (Klein, 2000, p. 27; Krasniewicz, 2000, p. 46). Arguably, examples such as these paved the way for metamorphosis in fluid letterforms by "spark[ing] the interest of the graphics community in metamorphosis techniques" (Gomes et al., 1999, p. 14). In contemporary motion graphics, metamorphosis of non-verbal graphical objects can be seen in examples such as Sehsucht's advertisement for Häagen Dazs (2010). In this animation, ice cream appears to melt and metamorphose into a leaping cat, before splitting into several additional fluid objects which themselves morph into flowers, birds, and curvilinear forms. Although this sequence does include a small number of morphing letterforms, most of the fluid objects presented never adopt a verbal identity. In this animation, the morphing forms cannot be distinguished from one another in the properties of their behavior; only by the fact that some do, and some do not, introduce verbal identities.

Norman Klein identifies a recent fatigue for digital morphing processes, caused largely by their overuse, reflected in a current trend for reviving manual methods. In Fallon's *"Play-Doh"* advertisement for Sony Bravia in 2007, stop-motion is used to transform colored modeling clay into hundreds of small rabbits which converge on a city square (Fallon, 2007). The brightly colored rabbits then merge together to form a colossal wave which rolls across the square, breaks apart into icebergs, and then merge together again to form a single giant rabbit. The scenes are filmed within a real urban environment, with onlookers and passing pedestrians. The jerky motion of these onlookers, and the surrounding everyday activity, draws attention to the stop-motion method (as opposed to digital imitations), and provides viewers with evidence of the considerable time and effort that was required for the production of the advert. These overtly handmade transformations reflect a general loss of respect for computer-generated trickery. As Klein (2000, p. 26) observes, processes such as the digital morph have become so familiar, and so simple to create, that audiences increasingly favor more time-consuming "handmade" methods.

Other kinds of transformation can also be seen in other on-screen artifacts, which could be described using terms presented in this book. Often, animation uses transformation as a metaphor. "Like verbal metaphors that involve relating seemingly disparate entities," entities can combine in on-screen transformation "to create new elements and new meaning" (Krasniewicz, 2000, pp. 54–5). Jan Svankmejer's *Dimensions of Dialogue* (1982) presents characters who are broken apart in representation of fierce argument and later merge into one another as they make love (Klein, 2000, p. 31). Here, different kinds of transformations are given distinctly different tones. Transformation by division into parts is presented as distinctly destructive and chaotic, whereas transformation through metamorphosis is presented as a positive process. When Svankmejer's subjects break apart and reform, the transformation is similar to that observed in fluid *construction*. Objects which have separate identities (fruit, or kitchen utensils) come together to construct the form of a human head. This behavior could be described as *construction through motion of parts* (see Chapter 5).

As with *metamorphosis*, both stop-motion and newer digital technologies have been utilized in order to create recent examples of *construction*. Matthew Roberts' promo for the *Sunday Times' Style* supplement (2009) uses stop-motion animation to construct a teapot. Initially, the animation presents an arrangement of paper cut-out circles. These come together and *overlap* to create a birds-eye-view of a teapot. The pile of flat circles is then substituted for a real teapot (in an act of *serial presentation*). This transformation highlights how objects can appear to be abstract when viewed from an unfamiliar angle. Alexey Devyanin and Nick Luchkiv's *Field* (2009, Plate 16), an experimental animation featuring alternative meanings of the word "field" in agriculture, mathematics, and physics, shows a computer-generated "mystical form" undergoing a series of transformations, each of which involves *construction through motion of parts*. As the animation begins, drops of water rise from the ground into the sky, pooling in the air to create an abstract floating structure. The liquid structure crystallizes and fragments. Its broken parts are then rearranged to form a rectangular structure. Close-ups reveal the alignment of the separate fragments, as they converge to become a single object.

Perhaps less frequently than *construction*, *revelation* is also present in non-linguistic artifacts. RSA Films' advertisement for Toyota reveals, in a single car, the four identities of Toyota's latest range. Each car is revealed sequentially, as drivers peel away the surface of their car to reveal

a different class of car beneath. This form of *revelation* mimics the theatrical sleight-of-hand that existed for many centuries before the introduction of screen-based technologies. Theatrical illusion often involves transformations of a similar kind, in which speed or "physical dexterity" combine to create unexpected and "striking transformations" (Solomon, 2000, p. 3). In Sichuan opera, this *revelation* of hidden identities becomes the focus of the performance. Performers change their masks on stage, in full view of their audience, using sleight-of-hand. In "bian lian" ("face changing," which originated in the seventeenth century), great skill is involved achieving change as quickly and smoothly as possible (Scott, 2008). One method, the "pulling mask," requires the performer to wear several layers of thin masks, which she or he peels off a layer at a time throughout the performance (Yu, 1996, p. 13). This centuries-old tradition has been updated for Western contemporary television and cinema in the form of prosthetic disguises, which are peeled back to reveal the true identity of a character, as in *Mission: Impossible* (Brian De Palma, 1996).

Just as in fluid artifacts, a single artifact may contain combinations of different kinds of transformation. Triada Studio's commercial for *Aregak* (2008) features an arrangement of buildings which transform through motion of parts into sequentially more advanced architectural structures. Each object unfolds as if it were a cardboard box, while other elements sprout from existing surfaces. This transformation is a complex hybrid of different forms of fluidity, with parts of the transformation being identifiable as *metamorphosis*, and others as *construction through motion of parts*.

These examples suggest that the categories of kineticism defined in this book may have applications in other screen-based practice, featuring pictorial and abstract subjects as opposed to letterforms. Much of the analysis that has taken place in this book is applicable to these non-verbal artifacts. Many contain, for example, what Kac (1997) describes as "in-between" states, in which objects are neither one thing nor another. Triada Studio's *Aregak* commercial, for example, features objects at the mid-point of a transformation that are neither one building nor another, and in that respect comparable to the asemic glyphs that exist mid-transformation in fluid typography.

It may even be possible to apply the terms and ideas presented in this book to artifacts that are not presented on the screen. Many screen-based fluid artifacts are inspired by other artifacts, and it is possible to look at these sources of inspiration for examples of fluid behaviors in other fields. Imaginary Forces' title sequence and teaser trailer for the film *Transformers* (Michael Bay, 2006) features a fluid behavior, *construction through motion of parts*. As described in Chapter 8, the sequence features large metallic letters which fracture and reform into an image of an "autobot." Alluding to the behavior of the titular robot "transformers," parts of the letters reconfigure into a pictorial arrangement (Ozler, 2006). This behavior was directly inspired by the transformations of the alien robots found in the Japanese television show, the *Transformers*, and the range of toys of the same name which can be manipulated so that they transform from one machine to another (Frasca, 2001). Though each Transformer is a single object, it is "designed to have two different states" and two different identities (ibid.). A Transformer may be both a robot and a plane, or a robot and a car, but not both simultaneously. One identity must be sacrificed in order to reveal the other, however the object itself is not destroyed during this process. It remains a complete Transformer throughout the transformation. Transformation is the defining feature of the *Transformers* franchise, to the extent that associated media, whether on-screen or off-screen, exhibit a similar behavior.

There is, therefore, potential to explore fluidity, and the various fluid behaviors, in on-screen and off-screen artifacts, ranging from graphical (but non-verbal) animations, to toys, or the everyday objects identified by Per Mollerup (1998) as "collapsibles." Each of the artifacts discussed here features a behavior similar to one identified in this book, and there is scope to conduct a study of kinetic behaviors in many fields, not just temporal typography.

Designers tasked with creating transformations recognize the similarities between the kinds of transformation seen in different artifacts, as is shown across the *Transformers* franchise, and in the imitation of certain notable transformations, such as those seen in the *Transformers* titles sequence, and other examples presented in this book, including, for example, the many Channel 4 idents. This acknowledgment of similarities between various artifacts is not, however, enough to allow for a sufficient understanding of fluid behaviors. In order for designers to sufficiently identify and understand their artifacts, and to help move their practice forward, there is a requirement for the application of precise terminology, such as the terms presented in this book.

Appendix: Categories of Temporal Typography

The following definitions outline the categories of behaviors exhibited in temporal typography, as defined in this book. The umbrella category of temporal typography can be identified as any typography or lettering that exists in different states at different times. It can be divided as follows:

Construction by parallax—A sub-category of construction, in which component parts, that are arranged across 3D space, appear to come into alignment as the viewer's viewpoint grants access to a parallax.

Construction through motion of parts—A sub-category of construction in which a whole letterform is created as its parts independently move into alignment.

Construction—A category of fluid typography in which letters are constructed from component parts, each of which has its own alternative identity. These letterforms are necessarily modular: built from separate component parts.

Dynamic layout—A sub-category of global motion. A typographic composition that is rearranged as letters or words relocate, changing their distance from the frame of the screen and from each other.

Elastic typography—A sub-category of local kineticism, in which letterforms appear malleable or pliable. Contours change, but the identity of the letterform remains intact.

Fluid typography—A sub-category of local kineticism, in which letterforms transform to the extent that they lose their initial identity and adopt an alternative, replacement identity, which may be pictorial, linguistic, or abstract.

Global motion—Words or letters that are relocated, but preserve their forms.

Kinetic typography—Encompasses all kinds of kineticism and motion in lettering and typography, in which letterforms move or change over time.

Local Kineticism—Change that affects the shapes of individual letterforms.

Metamorphosis—A category of fluid typography in which letters are malformed by their fluctuating contours, and thereby reform into a different letter or shape.

Revelation by color or illumination—A sub-category of revelation, in which letterforms are revealed through changes in lighting and color. Shifts in color or illumination may pick a letterform out from its backdrop, separating figure from ground. This may include the illumination of the letterform itself, or the space around it so that the letterform casts a shadow.

Revelation by rotation or navigation—A sub-category of revelation, in which letterforms are revealed as a scene is rearranged. Objects may revolve or move so that it becomes evident that they are letters. The viewer may navigate around the scene to reveal that those objects are letters. On a screen, these experiences of rotation or navigation are equivalent, as navigation is virtual and therefore presents the same screen-image as moving or revolving objects.

Revelation—A sub-category of fluid typography, in which a letterform that has previously been hidden is revealed to exist within a scene. It initially masquerades as another object or part of a scene, but its true alphanumerical identity is revealed over time.

Scrolling typography—A sub-category of global motion. A typographic arrangement that is relocated, so that the distance between the frame and the screen changes, but the layout of the type or lettering remains fixed.

Serial presentation—Static typographic arrangements, presented sequentially. These may be subjected to cinematic transitions, such as fades or wipes.

Notes

Property of
Fort Bend County Libraries
Not for Resale

Introduction

1 See, for example, the numerous animations on YouTube that are described and titled by their creators through direct reference to Kyle Cooper's *Transformers* sequence.

2 Max Warner, for example, describes his MTV ident as presenting a "morph," yet this animation does not present the kind of "smooth transition" that Coquaillart and Jancéne's (1991, p. 23) text on metamorphosis state is a requirement of a morph. Close inspection reveals that the "M" is constructed from moving panels which begin in a disorderly array and then rotate and align, locking together to form the contours of a single letter object. Warner's misuse of the term "morph" would perhaps be understandable if the ident were to belong to a tradition of morphing objects, however, other MTV idents are also constructed from moving parts.

3 See, for example, how Paul Grainge (2009) describes the behaviors exhibited in MPC's *Atlas* idents only by likening them to those previously created by Martin Lambie Nairn.

4 By classifying artifacts of temporal typography according to the medium in which they exist, Woolman and Bellantoni (1999 and 2000) have missed opportunities to explore the similarities and differences that often exist across different media.

Chapter 1

1 There are numerous guidelines governing typographic composition, largely based on a grid structure. See, for example, those proposed in Jan Tschichold's *The New Typography* (1998 [1928]). In print, these rules have been strictly adhered to, or defied, throughout the history of typography. In all cases, attempts are made to produce a composition that suits the purpose of the typographic work.

Chapter 2

1 Soo C. Hostetler (2006) defines "kinetic typography" simply as "the combination of typography and motion," and goes on to identify its common attributes. She describes how a letterform may become "abstract," no longer identifiable as a letter, because it has been "manipulated by distortion, texture [or] enlargement." However, she fails to discuss this issue further, and misses the opportunity to speculate as to the possible consequences of this change, or identify it as significantly different to type which simply moves.

2 For example, the website *AETuts* offers a tutorial instructing After Effects users on how to present typography that appears to be distorted by the rippling of a water surface (Bogdanov, 2009).

Chapter 3

1 Lee, Forlizzi and Hudson (2003, p. 84) acknowledge that "malleable" letterforms may be dramatically "manipulated," but only insofar as they "appear to be completely different type faces." This does not allow for more extreme manipulation, which would result in a form becoming unrecognizable as a verbal form, or adopting a new abstract or possibly pictorial identity. Woolman and Bellantoni (2000, pp. 36, 34) also acknowledge that text may "transform" or "distort," through "blurring, fracturing and cropping," and that on-screen type may present "transitions between the characteristics of a letter." However, their descriptions imply that these changes are slight, subtly altering legibility and mood but not resulting in total change.

2 Notable metamorphoses in literature include that of Kafka's Gregor Samsa into a cockroach (*Metamorphosis*, 1913), numerous transformations in Ovid's *Metamorphoses* (20BC–14AD), and Shakespeare's *A Midsummer Night's Dream* (1593–4).

Chapter 4

1 Three-dimensional type did exist in many forms before the invention of the screen. In moveable type (as in Gutenberg's printing press), 2D type is created from 3D casts of reverse letterforms; illusionistic 3D letterforms appear in nineteenth-century woodblock typefaces such as Robert Thorne's *Thorne Shaded*, c. 1810; signage also frequently involves extruded letterforms.

2 Similarly, relative sizes will be judged according to the perception that they are located at different distances (Rock, 1997, p. 374).

3 Both Roland Barthes (1977 [1961] , p. 17) and Charles Peirce ([1931–5] 2002) acknowledge the trap of interpreting photographs, and as implied by extension, film, as an accurate representation of reality. While semioticians stress that efforts should be made to understand that most photographed or filmed scenes are staged or artificial in other ways, there is an expectation among viewers that their "appearance corresponds to a reality." This reality would not be expected to include signs from a verbal paradigm, except when contained within likely graphical artifacts, such as signage.

4 This plausibility is key in establishing spectacle comparable to that of theatrical illusion (Slater, 1995, p. 232).

5 For viewers who have already encountered one of these idents, the revelation of the "4" is expected. The "real-life" introductory moments become a period of anticipation. This expectation has been exploited in MPC's recent Channel 4 idents, as will be explored in Chapter 6.

6 Kac uses this term only once among his many papers, and does not discuss it, suggesting that he has considered anamorphosis in hindsight rather than as fundamental to the initial development of his holopoems.

7 While the 3D woodblock typefaces on the nineteenth century appeared to represent dimensional objects, it is worth noting that the woodblocks themselves were 3D, with printers often using both the front and back faces of a block for different letters.

Chapter 5

1 The number of credits listed in recent title sequences is increasingly abbreviated. This omission of key text information would suggest that title sequences are often not read by viewers, or that filmmakers do not consider their verbal content to be as important as other features.

2 The visual information in a title sequence tends to relate to the fiction contained within a film, whereas the verbal information tends to describe the reality of film production. In suspending disbelief, the viewer must prioritize the experience of the film over how it was produced, making the appearance of the title sequence more valuable to their viewing than the information provided by the credits.

3 Roy Harris (1995, p. 86) and Brett Wilbur (2009) observe that children, before learning to write, will invent asemic characters in "pseudo-writing."

Chapter 6

1 Oulipo—"Ouvroir de littérature potentielle" (the workshop for potential literature)—was a group of poststructuralist writers and mathematicians that emerged in France in the 1960s. They produced experimental writings, many of which were interactive.

Chapter 7

1 For viewers who have already encountered one of these idents, the revelation of the "4" is expected. The everyday introductory moments become a period of anticipation.

Chapter 8

1 Ellen Seiter's (1987, pp. 32–8) semiotic analysis of the credit sequence for *The Cosby Show*, for example, describes and analyzes minute details of the actors' appearance and actions, including the colors of every garment they wear, and the various positions of their limbs as they dance, but does not even identify the color or style of the overlaid graphics, nor does it describe how the text appears or moves. It appears that she has considered the appearance and behavior of the actors as vital, but the appearance and behaviors of the typography as inconsequential. Similarly, despite providing a useful demonstration of the semiotic analysis of title sequences, Laudisio's (2010) analysis of *The Sopranos* title sequence does not mention the overlaid typographic elements, focusing instead on the live-action footage behind it. In her analysis of the credit sequence for *Deadwood*, Amanda Ann Klein (2006, p. 97) observes how imagery signifies aspects of America's wild west, by connoting, for example, "the arrival of civilisation" in a "savage" land, but does not identify how the overlaid typography may or may not contribute to these messages. In his comparative analysis of hospital drama title sequences, Jason Jacobs (2001, p. 438) even goes so far as to suggest that "our judgement of them will not need to spend much time on" the "communicative" elements, since, he argues, "a basic competent rendering of the show's title … is likely to be successful in this respect."

2 See numerous other fluid artifacts on Vimeo that imitate the transformation seen in Cooper's *Transformers* title sequence, and described using direct reference to "transformers" rather than

to a particular kind of kineticism, including Timo Design's *Animation Transformers* (2010), Wayne Dahlberg's *Transformers* (2010), and Marco Dell'sna's *Plasm Transformers* (2010).

3 According to the Gestalt law of Prägnanz.

4 The viewer perceives a 3D revolving object as this is the simplest possible interpretation. The alternative would be to perceive a form with fluctuating contours, but this is unlikely as viewers tend to assume that there is "shape constancy": "an implicit assumption that objects are permanent" (Rock, 1975, pp. 36, 69, 10).

Chapter 9

1 Some Gestaltists argue that "global" identity is "primary," while others "believe the reverse to be true" (Rock and Palmer, 1994, pp. 87–8).

2 *Beer* was distributed in Zervos' own CD ROM collection of cyberpoetry, and via websites including *Other Voices*, where it is framed in a poetry context. The work is discussed by Hazel Smith (2005) alongside other poetic works. These contexts clearly identify the work as poetry, and so invite certain expectations about the content and reception of the piece.

Bibliography

Aarseth, E. J. (1997), *Cybertext: Perspectives on Ergodic Literature,* Baltimore: John Hopkins University Press.

Ahn, M., and Lee, S. (2002), "Mesh Metamorphosis with Topology Transformations," *Computer Graphics and Applications: Proceedings of the 10th Pacific Conference on Computer Graphics and Applications*: pp. 481–2.

Ahn, Y. and Jin, G. (2013), "TYPE + CODE II: A Code Driven Typography," *Proceedings of the IEEE VIS Arts Program (VISAP).* http://visap2013.sista.arizona.edu/papers/Ahn_TypeCodeII.pdf (accessed October 30, 2013).

Andre, J. and Girou, D. (1999), "Father Truchet, the Typographic Point, the Romain du Roi, and Tilings," *TUGboat* 20, no. 1: pp. 8–14.

ATypI (No date), "Type Classification-ATypI," http://www.atypi.org/members/special-interest-groups/type-classification (accessed February 10, 2010).

Bachfischer, G. and Robertson, T. (2005), "From Movable Type to Moving Type—Evolution in Technological Mediated Typography," paper presented at the *Apple University Consortium Conference.*

Barthes, R. (1967), *Elements of Semiology,* translated by Annette Laves, London: Jonathan Cape.

—(1977 [1961]), "The Photographic Message," in *Image Music Text*, translated by S. Heath, London: Fontana Press, London, pp. 15–31.

—(1977 [1964]), "The Rhetoric of the Image," in *Image Music Text*, S. Heath (trans.), London: Fontana Press, London, pp. 32–51.

—(1977 [1968]), "The Death of the Author," in *Image Music Text*, by S. Heath (trans.), London: Fontana Press, London, pp. 142–8.

Bartram, A. (2005), *Futurist Typography and the Liberated Text,* London: The British Library.

Beccue, B. and Vila, J. (2004), "Assessing the Impact of Rapid Serial Visual Presentation (RSVP): A Reading Technique," in *Lecture Notes in Computer Science* 3061: pp. 42–53.

Bennet, N. (2007), "Poetry In Motion," *Digital Arts* (January 2007). http://www.digitalartsonline.co.uk/features/index.cfm?featureid=1547 (accessed July, 2011).

Biggs, M. A. R. (2004), "What Characterizes Pictures and Text?" *Literary and Linguistic Computing* 19, no. 3: pp. 265–72.

Bignell, J. (2002), *Media Semiotics: An Introduction.* 2nd edn, Manchester: Manchester University Press.

Bil'sk, P. (2005), "In Search of a Comprehensive Type Design Theory," *Typotheque.* http://www.typotheque.com/articles/in_search_of_a_comprehensive_type_design_theory (accessed July 13, 2011).

Block, J. R. (2002), "What is an Illusion?" *Sandlot Science.* http://www.sandlotscience.com/EyeonIllusions/whatisanillusion.htm (accessed July 19, 2011).

Bogdanov, E. (2009), "Create an Underwater Scene," *AETuts.* http://ae.tutsplus.com/tutorials/motion-graphics/create-an-underwater-scene/ (accessed October 22, 2013).

Bork, A. (1983), "A Preliminary Taxonomy of Ways of Displaying Text on Screens," *Information Design Journal* 3, no. 3: pp. 206–14.

Borzyskowski, G. (2004), "Animated Text: More than Meets the Eye?" *Beyond the Comfort Zone: Proceedings of the 21st ASCILITE Conference*: pp. 141–4. http://www.ascilite.org.au/conferences/perth04/procs/borzykowski.html (accessed July 13, 2011).

Brill, L. (1995), "Poetry in Motion in the Space-time Continuum," in *Holopoetry: Essays, Manifestos, Critical and Theoretical Writings,* Lexington: New Media Editions, pp. 52–3. Originally published in *Computer Graphics World* 12, no. 11 (November 1992): pp. 2–7.

Brownie, B. (2011), "Fluid Typography: Construction, Metamorphosis and Revelation," in G. Lees-Maffei (ed.), *Writing Design: Words and Objects,* Oxford: Berg, pp. 175–86.

—(2012), "The Behaviours of Fluid Characterforms in Temporal Typography," PhD thesis, University of Hertfordshire.

—(2013), "Modular Construction and Anamorphosis in Channel 4 Idents: Past and Present," *Journal of Media Practice* 14, no. 2: 93–110.

—(2014), "A New History of Temporal Typography: Towards Fluid Letterforms," *Journal of Design History* 26, issue 4: pp. 167–81.

Bukatman, S. (2000), "Taking Shape: Morphing and the Performance of Self," in V. Sobchack (ed.), *Meta-Morphing: Visual Culture and the Culture of Quick Change,* Minneapolis: University of Minnesota Press, pp. 225–49.

Castelhano, M. S., and Muter, P. (2001), "Optimizing the Reading of Electronic Text using Rapid Serial Visual Presentation." *Behaviour & Information Technology* 20, no. 4: 237–47.

Chandler, D. (2007), *Semiotics: The Basics,* 2nd edn, Oxon: Routledge.

Chang, D., Dooley, L., and Tuovinen, J. E. (2002), "Gestalt Theory in Visual Screen Design—A New Look at an Old Subject," *CRPIT '02 Proceedings of the Seventh World Conference on Computers in Education: Australian topics* 8. http://dl.acm.org/citation.cfm?id=820062&dl=ACM&coll=DL&CFID=78073609&CFTOKEN=85642032 (accessed April 18, 2012).

Cho, P. (1997), "Pliant Type: Development and Temporal Manipulation of Expressive, Malleable Typography," BSc diss., MIT. http://hdl.handle.net/1721.1/10553 (accessed July 13, 2011).

Condrington, A. (2003), *Kyle Cooper,* London: Laurence King.

Cooper, K. (2009), "Kyle Cooper Interview," *Forget the Film, Watch the Titles.* http://www.watchthetitles.com/articles/00170-Kyle_Cooper_interview_pt_1_2 (accessed October 20, 2013).

Coquaillart, S. and Jancéne, P. (1991), "Animated Free-Form Deformation: An Interactive Animation Technique," *Computer Graphics* 25, no. 4: 23–6.

Crasner, J. S. (2008), *Motion Graphic Design: Applied History and Aesthetics,* Oxford: Focal Press.

Crow, D. (2006), *Left to Right,* Switzerland: AVA.

Damisch, H. (2002), *A Theory of Cloud: Toward a History of Painting,* Stanford, CA: Stanford University Press.

De Ana, M. C. (2009), "Tomorrow is Forever: Examining Narrative Structure and Cultural Archetypes in Three Mexican Telenovelas," MA Thesis, University of Alabama. http://acumen.lib.ua.edu/content/u0015/0000001/0000050/u0015_0000001_0000050.pdf (accessed April 25, 2012).

De L'imprimerie Royale (1702), *Medailles sur les principaux évenements du regne de Louis le Grand, avec des explications historiques,* Paris.

Dixon, C. (2002), "Typeface Classification," paper presented at *Twentieth Century Graphic Communication; Technology, Society and Culture,* Annual Conference of the friends of St. Bride, London. http://www.stbride.org/friends/conference/twentiethcenturygraphiccommunication/TypefaceClassification.html (accessed July 21, 2011).

Docherty, D., Morison, D. E. and Tracey, M. (1998), *Keeping Faith? Channel Four and its Audience,* London: John Libbey.

Donaldson, T. (2009), "Practitioner Presentation," paper presented at *Beyond the Margins,* Cambridge, 12 September.

Drucker, J. (1991), "Typographic Manipulation of the Poetic Text in the Early Twentieth-Century Avant-Garde," *Visible Language* 25: 231–56.

—(2004), "What is a Letter?" in S. Heller (ed.), *The Education of a Typographer,* New York: Allworth Press, pp. 78–90.

Ellis, W. D. (1938), *A Source Book of Gestalt Psychology,* London: Routledge & Kegan Paul Ltd.

Engel, B., Ditterline, P., and Yeung, B. (2000), "The Effects of Kinetic Typography on Readability," diss., Carnegie Mellon University. http://a.parsons.edu/~garyj320/05f/kinetictypography.pdf (accessed July 19, 2011).

Ensslin, A. (2007), *Canonizing Hypertext: Explorations and Constructions,* London: Continuum.

Fanthome, C. (2007), "Creating an Iconic Brand—an Account of the History, Development Context and Significance of Channel 4's Idents," *Journal of Media Practice* 8, no. 3: 255–71.

Fink, K. (1991), "Impossible Figures in Perceptual Psychology," *Pitzer Psychology 106—Perception.*

Fisher, K. (2000), "Tracing the Tesseract: A Conceptual Prehistory of the Morph," in V. Sobchack (ed.) *Meta-Morphing: Visual Culture and the Culture of Quick Change,* Minneapolis: University of Minnesota Press, pp. 103–29.

Flusser, V. (1991), "The Gesture of Writing," *New Writing: the International Journal for the Practice and Theory of Creative Writing* 9, no. 1: 24–41.

Foakes, R. A. (1989), "Making and Breaking Dramatic Illusion," in F. Burwick and Pape, W. (eds), *Aesthetic Illusion: Theoretical and Historical Approaches,* New York: Walter de Gruyter, pp. 217–28.

Fong, K. (2001), "A Moment for Surprise," *Trace: AIGA Journal of Design* 1, no. 1: 30–9.

Ford, S., Forlizzi, J. and Ishizaki, S. (1997), "Kinetic Typography: Issues in Time-based Presentation of Text," *CHI 97 Late Breaking/Short Demonstrations*: 269–70.

Forlizzi, J., Lee, J. and Hudson, S. E. (2003), "The Kinedit System: Affective Messages Using Dynamic Texts," *Proceedings of the SIGCHI Conference on Human Factors in Computing Systems*: 377–84.

Frasca, G. (2001), "Videogames of the Oppressed: Videogames as a Means for Critical Thinking and Debate," MSc thesis, Georgia Institute of Technology. http://www.ludology.org/articles/thesis/FrascaThesisVideogames.pdf (accessed July 19, 2011).

Furniss, T. and Bath, M. (2007), *Reading Poetry: An Introduction,* Harlow: Pearson Education.

Galin, E. and Akkouche, S. (1996), "Blob Metamorphosis Based on Minkowski Sums." *Eurographics* 15, no. 3: 143–53.

Gaze, T. (2008a), *Asemic Movement* 1. http://vugg.wippiespace.com/vugg/gaze/asemicmovement1.pdf (accessed July 13, 2011).

—(2008b), *Asemic Movement* 2. http://vugg.wippiespace.com/vugg/gaze/asemicmovement2.pdf (accessed July 19, 2011).

Giampietro, R. (2013), interviewed in Maschmeyer, Leland (2013), *A Short Film for the Type Directors Club.* http://e.tdc.org/ (accessed October 29, 2013).

Gomes, J., Darsa, L., Costa, B. and Velho, L. (1999), *Warping and Morphing of Graphical Objects*, San Francisco: Morgan Kaufmann Publishers.

Grainge, P. (2009), "Lost Logos: Channel 4 and the Branding of American Event Television," in Pearson, R. E. (eds.), *Reading Lost*, London: I. B. Taurus, pp. 95–115.

Gray, N. (1982), *Lettering as Drawing,* New York: Taplinger.

Gross, S. (1997), "The Word Turned Image: Reading Pattern Poems," *Poetics Today* 18, no. 1: 15–32.

Hall, S. (1980), *Encoding/Decoding*, as cited in Rojek, Chris (2009), "Stuart Hall on Representation and Ideology," in R. Hammer and D. Kellner, (eds), *Media/Cultural Studies: Critical Approaches*, New York: Peter Lang, pp. 49–62.

Harris, R. (1995), *Signs of Writing,* New York: Routledge.

Hawkes, T. (1977), *Structuralism and Semiotics*. London: Methuen & Co. Ltd.

Helfand, J. ([1994] 1997), "Electronic Typography: The New Visual Language," in M. Beirut, W. Drenttel, and S. Heller, (eds), *Looking Closer 2: Critical Writings on Graphic Design*, New York: Allworth Press, pp. 49–53. Originally published in *Print* May/June 1994.

Heller, S. and Thompson, C. (2000), *Letterforms: Bawdy Bad & Beautiful,* New York: Watson-Gupthill.

Heusser, J., Montgomery, J., and Seymour, S. (2007), "MPC London's Award Winning Channel 4 Idents," *FX Guide.* http://www.fxguide.com/featured/MPC_Londons_Award_Winning_Channel_4_Idents/ (accessed July 19, 2011).

Hillner, M. (2005), "Text in (e)motion," *Visual Communication* 4, no. 2: 165–71.

—(2006), "Virtual Typography: Time Perception in Relation to Digital Communication," *Leonardo Electronic Almanac* 14, no. 5–6.

—(2007), "The Poetics of Transition: The Ambiguous Characteristics of Virtual Typography," MPhil thesis, Royal College of Art.

—(2009), "Virtual(ly) Typography—Towards a Notion of Poetics," *Icograda*. http://www.icograda. org/feature/currrent/articles291.htm (accessed July 13, 2011). Originally published in *Leonardo Electronic Almanac* 19, no. 5.

Hochberg, J. (1981), "Levels of Perceptual Organization," in M. Kubovy and J. R. Pomerantz, (eds), *Perceptual Organization*. New Jersey: Laurence Erlbaum Associates, pp. 255–78.

Hoefler, J. (2001), "On Classifying Type," in Heller, Steven and Meggs, Phillip B. (eds), *Texts on Type: Critical 2001 on Typography*, New York: Allworth Press, pp. 201–9. Originally published in *Émigré* 42.

Holemstein, E. (1983), "Double Articulation in Writing," in F. Coulmas and K. Ehlich, (eds), *Writing in Focus,* New York: Walter de Gruyter, pp. 45–62.

Hoppe, P. (2011), "Exploratorium," *Paul Hoppe Design*. http://www.paulhoppedesign.com/ exploratorium (accessed November 15, 2013).

Hostetler, S. C. (2006), "Integrating Typography and Motion in Visual Communication," paper presented at the *2006 iDMAa and IMS conference,* Miami, April 6–8. http://www.units.muohio. edu/codeconference/papers/papers/Soo%20Hostetler–2006%20iDMAa%20Full%20Paper.pdf (accessed July 13, 2011).

Hutchings, R. S. (1964), *Alphabet 1964: International Annual of Letterforms,* Birmingham: Kynoch Press.

Ikonen, T. (2003), "Moving Text in Avant-Garde Poetry: Towards a Poetics of Textual Motion," *Dichtung-digital.de* 4, no. 30.

Inceer, M. (2007), "An Analysis of the Opening Credit Sequence in Film," *CUREJ: College Undergraduate Research Electronic Journal* 65.

Ingold, T. (2007), *Lines: A Brief History*. London: Routledge.

Ivarsson, J. (2004), *A Short Technical History of Subtitles in Europe*. http://www.transedit.se/history. htm (accessed February 5, 2009).

Jacobs, J. (2001), "Issues of judgement and value in television studies," *International Journal of Culture Studies* 4, no. 4: 427–47.

Johnston, D. J. (2009), "New Media Jelly: Motile Typography in a Programmable Era," paper presented at *Beyond the Margins*, Cambridge, September 12.

Jun, S. (2000), "The New Typography Today: Issues in Kinetic Typography from the Perspective of Jan Tschichold," MA diss., Carnegie Mellon University. http://www.contrib.andrew.cmu.edu/~soojin/ documents/Jun_2000_new_typography_today.pdf (accessed July 13, 2011).

Jury, D. (2004), *About Face: Reviving the Rules of Typography*. Hove: Rotovision.

Kac, E. (1995), *Holopoetry: Essays, Manifestos, Critical and Theoretical Writings,* Lexington: New Media Editions. http://www.ekac.org/holopoetrybook.pdf (accessed July 19, 2011).

—(1997 [1996]), "Key Concepts of Holopoetry." *Electronic Book Review*. Originally published in Jacksin, D., Vos, E. and Drucker, J. (eds), *Experimental-Visual-Concrete: Avant-Garde Poetry Since the 1960s*. Edited by Amsterdam-Atlanta: Rodopi, pp. 247–57.

—(1999), "Complete List of Holopoems (1983–1993)." *Kac Web*. http://www.ekac.org/allholopoems. html (accessed July 13, 2011).

—(2007), *Hodibis Potax*. Ivry-Sur-Seine: Édition Action Poétique.

King, D. B. and Wertheimer, M. (2005), *Max Wertheimer and Gestalt Theory,* 2nd edn. New Jersey: Transaction Publishers.

King, E. (1993), "Taking Credit: Film Title Sequences, 1955–1965/ 7: Sex and Typography: From Russia With Love," *Typotheque*. http://www.typotheque.com/articles/taking_credit_film_title_ sequences_1955–1965_7_sex_and_typography_from_russia_with_love_1963# (accessed July 13, 2011).

—(2005), "Robert Brownjohn: Design his Way," *Designboom.* http://www.designboom.com/brownjohn.html (accessed July 19, 2011). Originally published in *Robert Brownjohn: Sex and Typography.* New York: Princeton Architectural Press.

Klein, A. A. (2006), "The Horse Doesn's Get a Credit: The Foregrounding of Generic Syntax in Deadwood's Opening Credits," in D. Lavery, (ed.), *Reading Deadwood,* London: I. B. Taurus, pp. 93–100.

Klein, N. M. (2000), "Animation and Animorphs: A Brief Disappearing Act," in V. Sobchack (ed.), *Meta-Morphing: Visual Culture and the Culture of Quick Change,* Minneapolis: University of Minnesota Press, pp. 21–39.

Krasniewicz, L. (2000), "Magical Transformations: Morphing and Metamorphosis in Two Cultures," in V. Sobchack (ed.), *Meta-Morphing: Visual Culture and the Culture of Quick Change,* Minneapolis: University of Minnesota Press, pp. 41–58.

Kubovy, M. and Pomerantz, J. R. (1981), *Perceptual Organization.* New Jersey: Laurence Erlbaum Associates.

Kulvicki, J. V. (2006), *On Images: Their Structure and Content.* Oxford: Oxford University Press.

Lamont, P., and Wiseman, R. (2005), *Magic in Theory: An Introduction to the Theoretical and Psychological Elements of Conjuring,* Hertfordshire: University of Hertfordshire Press.

Lang, R. J. (2003), *Origami Design Secrets: Mathematical Methods for an Ancient Art,* Massachusetts: A K Peters.

Lapacherie, J.-G., and Lehmann, A. (1994), "Typographic characters: tension between text and drawing," *Yale French Studies* 48: 63–77.

Laudisio, J. (2010), "Media Analysis: The Sopranos" Title Sequence," *A Collection of Essays, Papers, and Ideas.* http://johnlaudisio.wordpress.com/20120/06/22/medi-analysis-the-sopranos/ (accessed April 25, 2012).

Lazarus, F. and Verrous, A. (1998), "Three-dimensional metamorphosis: a survey," *The Visual Computer* 4: 373–89.

Lee, B. (1997), *Talking Heads: Language, Metalanguage, and the Semiotics of Subjectivity,* Durham, NC: Duke University Press.

Lee, J. C., Forlizzi, J. and Hudson, S. E. (2002), "The kinetic typography engine: an extensible system for animating expressive text," *Proceedings of the 15th Annual ACM Symposium on User Interface Software and Technology:* 81–90.

Lee, S. Y. (2007), "Finding New Aspects of Typeface / Research on Interactive Dimensional Typography." http://www.soong-me.com/paper.pdf (accessed June 2, 2010).

Leung, S. and Kapla, J. A. (1999), "Pseudo-languages: a conversation with Wenda Gu, Xu Bing, and Jonathan Hay." *Art Journal* 58, no. 3: 86–99.

Lewis, D. (2001), *Reading Contemporary Picturebooks.* London: Routledge.

Lewis, J. E., and Nadeau, B. (2009), "Writing with Complex Type," *Proceedings of the Digital Arts and Culture 2009 Conference.* http://bruno.wyldco.com/papers/LewisNadeau-ComplexType.pdf (accessed July 13, 2011).

Longrée, G. (1976), "The rhetoric of a picture poem," *PLT* 1, no. 1: 63–84.

Manovich, L. (2001), *The Language of New Media,* London: MIT Press.

Massin (1970), *Letter and Image,* London: Studio Vista.

Miller, J. A. (1996), *Dimensional Typography,* New York: Princeton Architectural Press.

Miller, J. A., and Lupton, E. (1992), "A Natural History of Typography," in Bierut, Michael (ed.), *Looking Closer: Critical Writings on Design,* New York: Allworth Press, pp. 19–25. Originally published in J. A. Miller and E. Lupton, (eds), *Design Writing Research,* New Jersey: New York and the Jersey City Museum.

Mills, M. (1993), "Herbert Bayer's Universal Type in its Historical Contexts," in E. Lupton and J. A. Miller (eds), *The ABCs of the Bauhaus and Design Theory,* London: Thames & Hudson, pp. 38–45.

Mollerup, P. (1998), *Marks of Excellence,* London: Phaidon.

—(2001), *Collapsibles: A Design Album of Space-Saving Objects,* London: Thames & Hudson.

MPC (2008), "Sky Rebrand." http://www.moving-picture.com/index.php?option=com_content&view=article&id=456&catid=38&Itemid=926 (accessed July 17, 2011).

Navas, E. (2003), Post on *Net Art Review*, 22 March. http://netartreview.net/logs/2003_03_16_backlog.html (accessed July 19, 2011).

Navon, D. (1977), "Forest before the trees: the precedence of global figures in visual perception," *Cognitive Psychology* 9: 353–83.

Noland, C. (2006), "Digital Gestures" in T. Swiss and A. Morris (eds), *New Media Poetries*, Cambridge, MA: MIT Press. http://www.uiowa.edu/~poroi/seminars/nmtt/resources/noland.doc (accessed July 19, 2011).

Olmstead, W. (1996), "On the margins of otherness: metamorphosis and identity in Homer, Ovid, Sidney and Milton." *New Literary History* 27, no. 2: 167–84.

Orban, C. E. (1997), *The Culture of Fragments: Words and Images in Futurism and Surrealism*, Amsterdam and Atlanta: Rodopi.

Ord, C. (2007), *Magic Moving Images: Animated Optical Illusions,* Tarquin Publications.

Orgdot (2002), "The ABC Game." http://www.orgdot.com/abc/ (accessed December 1, 2013).

—(2007), "Channel 4 Brings Its Logo to Life to Launch Big Art in 2008," *Dexigner*. http://www.dexigner.com/news/12348 (accessed July 19, 2011).

Ozler, L. (2006), "Imaginary Forces Designs Mega Titles in Transformers Teaser Trailer," *Dexigner*. http://www.dexigner.com/design_news/6922.html (accessed July 19, 2011).

Palmer, S., Simone, E. and Kube, P. (1988), "Reference frame effects on shape perception in two versus three dimensions." *Perception* 17, no. 2: 147–63.

Patterson, J. (2011), "LAIKA: A Dynamic and Responsive Typeface," *Design.org.* http://design.org/blog/laika-dynamic-and-responsive-typeface (accessed October 29, 2013).

Peirce, C. (2002 [1931–5]), *Collected Writings*, Cambridge, MA: Harvard University Press, 1931–5, as cited in Chandler, Chandler, Daniel (2007), *Semiotics: The Basics*, 2nd edn, Oxon: Routledge, p. 42.

Pipes, A. (2005), *Production for Graphic Designers*. 4th edn. London: Laurence King.

Pomerantz, J. R., and Kubovy, M. (1981), "Perceptual Organization: An Overview," in M. Kubovy, and J. R. Pomerantz, (eds), *Perceptual Organization*, New Jersey: Lawrence Erlbaum Associates, pp. 423–56.

Rock, I. (1975), *An Introduction to Perception*, New York: Macmillan.

—(1997), *Indirect Perception,* Cambridge, MA: MIT Press.

Rock, I. and Palmer, S. (1990), "The legacy of Gestalt psychology," *Scientific American* 263, Issue 6: 84–90.

Rock I., and Palmer, S. (1994), "Rethinking perceptual organisation: the role of uniform connectedness," *Psychonomic Bulletin & Review* 1: 29–55.

Rose, G. (2007), *Visual Methodologies*, 2nd edn, London: Sage.

Ryan, D. (2001), *Letter Perfect: The Art of Modernist Typography 1896–1953*, California: Pomegranate.

Ryan, M.-L. (1999), *Cyberspace Textuality: Computer Technology and Literary Theory*, Bloomington: Indiana University Press.

Sapnar, M. (2003) "Reactive Media Meets e-poetry," *Poems that Go* 12. http://www.poemsthatgo.com/gallery/winter2003/print_article.htm (accessed July 19, 2011).

Saussure, F. de. (1983 [1913]), *Course in General Linguistics*, London: Duckworth.

Schwenger, P. (2012), "Asemic Writing: Backwards into the Future," paper presented at the *Communication & Aesthetics Theories Revisited Conference*, Winnipeg, Canada, 31 May–1 June. http://vimeo.com/43221281 (accessed October 22, 2013).

Scott, J. (2008), "A dialogue between Sichuan and Beijing opera (review)," *Asian Theatre Journal* 25, no. 2: 370–3.

Search, P. (1995), "The semiotics of the digital image." *Leonardo* 28, no. 4: 311–17.

Seiter, E. (1987), "Semiotics, Structuralism and Television," in R. Clyde Allen (ed.), *Channels of Discourse: Television and Contemporary Criticism*. London: Methuen, pp. 17–41.

Shaw, G. L., and Ramachandran, V. S. (1982), "Interpolation during apparent motion," *Perception* 11, no. 4: 491–4.

Skolos, N. and Wedell, T. (2006), *Type, Image, Message: A Graphic Design Layout Workshop*, Gloucester, MA: Rockport.

Slater, D. (1995),"Photography and Modern Vision: The Spectacle of Natural Magic," in C. Jenks (ed.), *Visual Culture*, London: Routledge, pp. 218–37.

Small, D. (1996), "Perception of Temporal Typography." http://citeseerx.ist.psu.edu/viewdoc/download?doi=10.1.1.35.3157&rep=rep1&type=pdf (accessed July 13, 2011).

—(1999), "Rethinking the Book," PhD diss., MIT. http://acg.media.edu/projects/thesis/DSThesis.pdf (accessed July 13, 2011).

Smith, H. (2005), "New Media Travels," *The Writing Experiment*, Sydney: Allen & Unwin.

Sobchack, V. (2000), "At the Still Point of the Turning World: Meta-Morphing and Meta-Stasis," in V. Sobchack (ed.), *Meta-Morphing: Visual Culture and the Culture of Quick Change*, Minneapolis: University of Minnesota Press, pp. 131–58.

Solomon, M. (2000), "Twenty-Five Heads under One Hat: Quick Change in the 1890s," in V. Sobchack (ed.), *Meta-Morphing: Visual Culture and the Culture of Quick Change*, Minneapolis: University of Minnesota Press, pp. 3–20.

Soo, D. (1997), "Implementation of a Temporal Typography System," Masters diss., MIT. http://mit.dspace.org/bitstream/handle/1721.1/10274/37145274.pdf?sequence=1 (accessed July 13, 2011).

Southall, R. (1993), "Presentation Rules & Rules of Composition," in *Computers and Typography*. Edited by Rosemary Sasson. Bristol: Intellect Books, pp. 32–50.

Specht, H. (2000), "Legibility: How Precedents Established in Print Impact On-Screen and Dynamic Typography," MFA diss., West Virginia University. https://eidr.wvu.edu/eidr/documentdata.eIDR?documentid=1426 (accessed July 13, 2011).

Spence, R. and Witkowski (2013), *Rapid Serial Visual Presentation: Design for Cognition*, London: Springer.

Stadler, J. (2002), "Losing the Plot: Narrative Understanding and Ethical Identity in *Lost Highway*," in K. L. Jefferson Stoehr (ed.), *Film and Knowledge: Essays on the Integration of Images and Idea*, North Carolina: McFarland & Company Ltd, pp. 17–36.

Surazhsky, T., Surazhsky, V., Barequet, G. and Tal, A. (2001), "Blending polygonal shapes with different topologies," *Computers & Graphics* 25: 29–39.

TDC (2001), "'Alphabot' Interactive Design Work," *TDC Annual Awards*. http://www.tdctokyo.org/awards/award01/01interactive_e.html (accessed July 13, 2011).

—(2013), "60th Annual Type Directors Club Call for Entries." https://www.tdc.org/type-competition/#sthash.oeb62IYM.dpuf (accessed October 30, 2013).

Tesauro, E. (2004), "Beyond Anamorphosis," in F. Varini, L. Müller and F. López-Durán (eds), *Felice Varini: Points of View*, Baden: Lars Müller Publishers.

Thompson Klein, J. (1990), *Interdisciplinarity: History, Theory, and Practice*, Detroit: Wayne State University Press.

Tschichold, J. (1998 [1928]), *The New Typography*, R. McLean (trans.), Los Angeles: University of California Press. Originally published as *Die Neue Typographie: Ein Handbuch für Zeitgemäss Schaffende*, Berlin: Brinkmann & Bose.

—(1997), *The Form of the Book: Essays on the Morality of Good Design*. Vancouver: Harley & Marks.

Tsur, R. (2000), "Picture poetry, mannerism, and sign relationships," *Poetics Today* 21, no. 4: 751–81.

Tubaro, A. and I. (1994), *Lettering*, London: Thames and Hudson.

Varga, A. Kibedi (1989), "Criteria for Describing Word and Image Relations," *Poetics Today* 10, no. 1: pp. 31–53.

Vox, M. (1954), *Nouvelle Classification des Characters*, Paris: Ecole Estienne. http://yharel.free.fr/data/informatique/logiciels/bureau/traintement_de_texte/typographie/typographie_caracteres.htm (accessed June 22, 2010).

Wagner, K. von (2006), "Gestalt Laws of Perceptual Organisation: The Law of Prägnanz," *About: Psychology.* http://psychology.about.com/od/sensationandperception/ss/Gestaltlaws_3.htm (accessed July 19, 2011).

Warde, B. (1930), "The Crystal Goblet or Printing Should Be Invisible," an address before the British Typographers" Guild at St. Bride's Institute, London. http://glia.ca/conu/digitalPoetics/ prehistoric-blog/wp-content/uploads/ward.pdf (accessed July 13, 2011). Reproduced from B. Warde, (1956), *The Crystal Goblet: Sixteen Essays on Typography,* Cleveland, pp. 11–17.

Weight, J. (2006), "I, apparatus: you: a technosocial introduction to creative practice," *Convergence: The International Journal of Research into New Media Technologies* 12, no. 4: 413–46.

WGBH Educational Foundation (1999), "Xu Bing's *A Book from the Sky,*" *Culture Shock.* http://www. pbs.org/wgbh/cultureshock/flashpoints/visualarts/xubing.html (accessed July 13, 2011).

White, A. W. (2005), *Thinking in Type: The Practical Philosophy of Typography,* New York: Allworth Communications.

Whittaker, H. (2005), "Social and symbolic aspects of minoan writing," *European Journal of Archaeology* 8, no. 1: 29–41.

Wilbur, B. M. (2009), "Finding Self in the Nuts and Bolts—Hidden Quality in the Service of Organisation." http://www.metaphorms.com/uploads/Microsoft_Word_-_Nuts_and_Bolts_article. pdf (accessed July 13, 2011).

Willen, B. and Strals, N. (2009), *Lettering & Type,* New York: Princeton Architectural Press.

Willows, P. (2005), "Gestalt psychology, semiotics and the modern Arab novel," *AS/SA* 15: 14–24.

Wolf, M. J. P. (2000), "A Brief History of Morphing," in V. Sobchack (ed.), *Meta-Morphing: Visual Culture and the Culture of Quick Change,* Minneapolis: University of Minnesota Press, pp. 83–101.

Wong, Y. Y. (1995), "Temporal Typography: Characterization of Time-varying Typographic Form." MS thesis, MIT. http://hdl.handle.net/1721.1/29102 (accessed July 19, 2011).

—(1996), "Temporal Typography: A Proposal to Enrich Written Expression," *CHI 96 Conference Proceedings.* http://acm.org/sigchi/chi96/proceedings/videos/Wong/yyw_txt.htm (accessed July 13, 2011).

Woolman, M. (2005), *Type in Motion 2,* London: Thames & Hudson.

Woolman, M. and Bellantoni, J. (1999), *Type in Motion: Innovations in Digital Graphics,* London: Thames & Hudson.

—(2000), *Moving Type,* Hove: Rotovision.

Worth, S. (1981), *Studying Visual Communication.* Philadelphia: University of Pennsylvania Press.

Worthington, M. (1998), "The new seduction: movable type," *AIGA Journal of Graphic Design* 16, no. 3: 9–10.

Yu, S.-L. (1996), *Chinese Drama after the Cultural Revolution: 1979–1989,* New York: Edwin Mellen Press.

Zervos, K. (2005), "Cyberpoetry Underground," *Other Voices International Project* 11.

Index

WITHDRAWN

Property of
Fort Bend County Libraries
Not for Resale

WITHDRAWN

Property of
Fort Bend County Libraries
Not for Resale